TAKING SUCCESSFUL PICTURES

Consultant Editor Christopher Angeloglou

Collins

Published in 1981 by
William Collins Sons & Co Ltd
London · Glasgow · Sydney ·
Auckland · Johannesburg

Designed and produced for
William Collins Sons & Co Ltd
by Eaglemoss Publications Limited

First published in *You and Your Camera*
© 1981 by Eaglemoss Publications Limited

ISBN 0 00 411683 6

Printed in Great Britain

CONTENTS

INTRODUCTION

As soon as you put a camera to your eye you are composing a picture. You have selected a subject, excluded others, and you are looking at it from a particular viewpoint. But the first glance through the viewfinder is unlikely to provide you with the most interesting or well-composed photograph. It may be better to move to a different viewpoint, to get nearer the subject, to find a more diffused source of light, or to turn the camera sideways to frame the shot vertically.

Taking Successful Pictures guides you through the basic elements of composition. Starting with the viewfinder it shows how important it is to look at the subject with an eye for how it will appear on a rectangular or square piece of paper. A shift of only a few centimetres can dramatically change the effect of a picture. Where should you put the horizon and how much foreground or background should you include? Would the shot be better in black and white, or in silhouette perhaps? How can perspective, texture, or tone be emphasized?

Filled with practical tips and examples from top-class photographers, each chapter covers a particular aspect of composition. By the end of the book you will have a clear sense of which elements to consider before pressing the button and how to view your subject with the eye of a professional.

Composing in the viewfinder

The panoramic view on the right is very much as the eye sees it—but the eye will subconsciously focus on certain details as it moves across the landscape. What each person notices is very much a personal choice—it may be the form of a particular tree, the pattern made by branches or the position of a figure.

When you take a photograph you make two decisions: *what* you are going to include and *when* to press the button. In both instances you need to consider how to show the subject in the most effective way.

Good composition may mean simplifying your photograph by changing viewpoint—moving higher, lower, more to one side. It certainly means thinking about the direction and quality of the lighting. This can make all the difference between a photograph which is muddled or boring, and one which looks right.

How to 'see' better pictures

Some people have a natural ability to see a composition right away—but most of us have to keep looking, experimenting, and looking again, until we start seeing well composed photographs. But remember, this is something anyone can do, no matter how simple or elaborate their camera.

Photography is concerned with seeing the world in terms of how it appears in a rectangular (or square) shape on a flat piece of paper. The question is, which parts of what you see should the camera include . . . or leave out? This depends not only on the main centre of interest but also on the visual appeal of shapes, colours, patterns, and textures. Moving around, looking through the viewfinder, helps you emphasize important aspects and isolate them from the overall view. Look also at the way objects may be cut by the edges of your picture. The hard lines at the edges of the viewfinder give a definite border to what you select. You might cut off a vital part of the subject by mistake—or use this border to contain the picture. This is another difference between seeing the scene as the human eye sees it and composing it into a photograph.

To become more aware of composition it is helpful to make a cardboard viewing frame. Look through it at familiar objects, parts of your home, people's faces or landscapes. It is surprising how, by imposing this frame on what you see, you start to discover interesting 'pictures' where you may not have noticed them before.

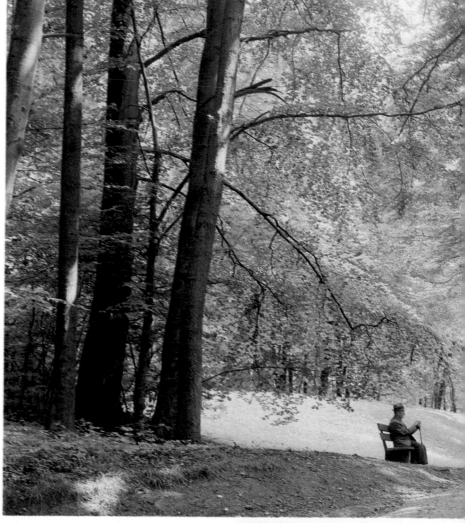

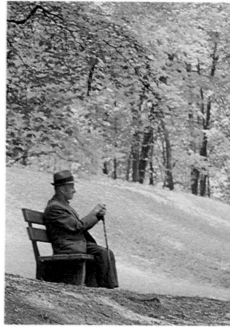

▶ With a camera the photographer can choose which part of the general view becomes the subject and a static scene, such as a landscape, gives time for careful composition in the viewfinder. Experiment by changing the camera position and moving in closer on parts of the scene to find out how this affects what you see in the viewfinder. Introducing figures into a landscape gives an immediate sense of scale and often contributes to the balance and interest of the composition.

▶ Centre: picking out a detail may say as much about a scene as the larger view. In a woodland the fresh green of leaves in spring create an unforgettable image, so why not go right in and capture that quality by filling the viewfinder entirely. The skill comes in *seeing* the detail and then isolating it from the overall view.

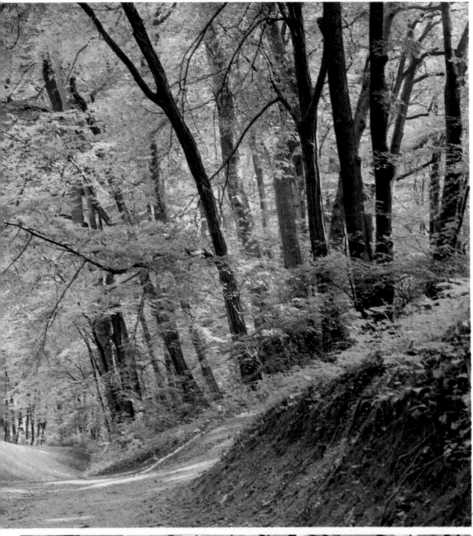

▼ Tall, slim trees just ask for a vertical format. By moving in close this picture emphasizes the soaring quality of the trees; patterns of light and shade; rough texture of bark against a lacy canopy of leaves. You can strengthen the vertical shape later by cutting the print—known as cropping—to make a narrower shape than the film format.

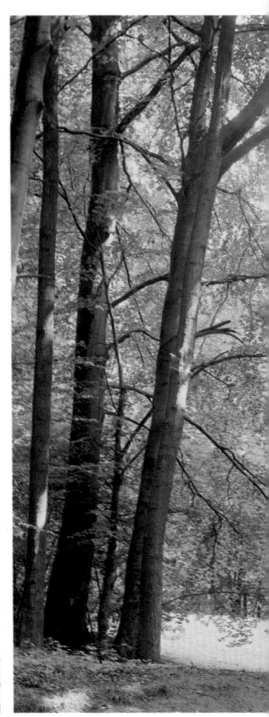

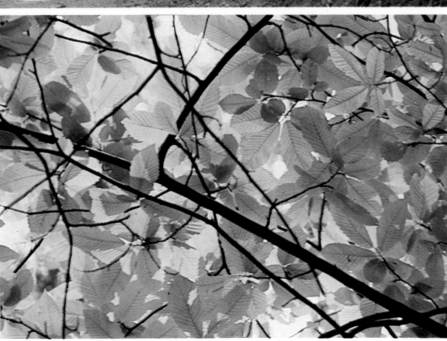

Using a viewfinder

Some people find the camera view-finder rather awkward and inhibiting—a mechanical block between them and the subject. This is where a cardboard viewing frame is useful. It helps to train the eye to see and compose successful pictures.

Whether you use a frame, or the camera itself, this section is concerned with exploring the effects of changing viewpoint. Even though you will usually be composing far more complicated pictures of groups of people, interiors, or landscapes it is well worth starting by looking at just one simple object and *seeing* it. Here you are dealing with three main elements: a) the subject, b) the rectangle or square imposed by the picture format, and c) the spaces around the subject.

As you look at the subject, notice how important the spaces around it are—both the shapes they make and the way the shadow falls. The strength, position and shape of the shadow help to define the subject's three–dimensional form.

What subject to choose?

This will depend on how close your camera lens can get to the subject—check the minimum focusing distance of your camera, then pick something that fills the viewfinder. If you can get as close as 45cm you might choose a china cup and saucer. If your minimum distance is about 90cm then choose something larger with an interesting shape, such as a chair or a watering can.

LONG VIEW
Start by looking at the subject from as far away as possible. Now move in, seeing how the subject looks on the right of the viewing frame, then on the left. In each case, is your eye led into, or out of, the frame?

CLOSE UP
Move in close until the subject fills the frame (try this out with both formats). The closer you get the more you become aware of the shape of the background, and how light and shadow give form to the subject.

DETAIL
Even if your camera lens does not let you get closer than 90cm, take a look at details through the viewing frame—the close–up view may be more intriguing and interesting lines, textures and patterns may emerge.

If you try this out using film, aim to have a neutral background, which does not interfere with the shape of the subject. You may be able to isolate the subject from distracting surroundings on a large piece of paper, in an empty room or passage, on a white sheet, or in the middle of a lawn. Position the subject and yourself so that the daylight lights the subject from the side. (Don't use flash as you cannot be sure what effect it will create.) With a simple subject like a chair, you have two choices—either to move the subject, or to move the camera. It's a good idea to get into the habit of moving the camera rather than the subject so that when you come to an immovable object, such as a tree you are used to moving around to find the best viewpoint.

The viewing frame

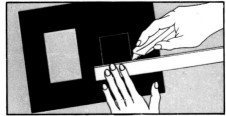 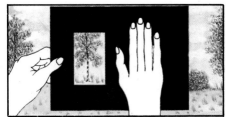

A colour–slide mount will do, but a larger, black cardboard frame helps to isolate the subject far better. You need a steel ruler, a sheet of matt black cardboard, about 30 x 23cm, a craft knife and a pencil.
Draw a rectangle in the proportion of 2:3, such as 4 x 6cm, and a square about 2 x 2cm, and cut out. Work on the black side to keep the edges crisp.

With the black side facing you, close one eye and look through the frame. Move it towards and away from you until the subject is framed in a pleasing way. Everyday objects can make effective pictures when they are cleverly positioned and background clutter is cut out.

Using the format

Basically, there are two photographic formats: square and rectangular. The size of the rectangle varies, but the proportion of 2:3 is generally appropriate for 110 and 35mm film. With a viewing frame in both shapes you can compare the effect of using the two formats—a useful point to consider when you buy a new camera. Some people are devoted to one format and find it hard to work with the other. Start by looking at the subject from the same viewpoint through one and then the other format and, of course, try the rectangle both horizontally and vertically.

LOW LEVEL VIEW
Now try a lower viewpoint: does the subject look most effective from ground level, or a little higher? Is the subject identifiable, or do you need to move around to find a better vantage point?

FROM ABOVE
With a plan view of the subject the shapes of the horizontal parts become important and the surface it stands on forms the background. A truly 'over the top' view often simplifies shapes and lines.

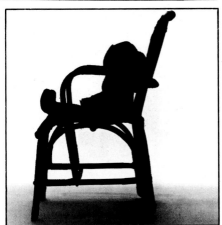

SILHOUETTE
Move directly opposite the light source, then adjust the viewing height until you achieve the most satisfactory silhouette. For a clear, clean shape the horizontal lines of the subject should suggest the correct height.

Where to put the horizon

In photography, as in painting, deciding where to place the horizon is an important way to give emphasis to your subject and to balance the picture as a whole. The horizon also gives a sense of scale to a landscape, whether it is a towering mountain range or a billiard table sea. The way you balance your composition adds to the visual impact of what you are trying to convey.

Horizontal or vertical?

Most cameras take photographs on a rectangular format. This gives you the choice between composing horizontal or vertical pictures.

Horizontal photographs, with the horizon running right across the picture, tend to emphasize the space from left to right. The viewer's gaze follows along the horizon in much the same way as when scanning words on a page. Using this format gives photographs a sense of 'wide open spaces', but you need to think about including some foreground objects as a way of giving a feeling of scale and perspective to the picture.

Vertical photographs can convey an immense feeling of depth depending on how the horizon is handled. The eye tends to 'read' the scene from foreground back and up to the sky. With a high viewpoint a great deal of detail can normally be included in this type of composition as the landscape appears to extend from the viewer's feet right up to the horizon and the sky.

When photographing a landscape, always keep training yourself to try composing both horizontally and vertically through the viewfinder or a viewing frame.

Where to put the horizon

The classic 'comfortable' position for the horizon is a third of the way down the frame. But if you want to create a more dramatic effect, consider positioning the skyline higher, much lower, or in the middle.

The classic solution

Most Western painters from the Renaissance, when they 'discovered' perspective, up to the end of the 19th century have been preoccupied with breaking down landscapes into foreground, middle distance, background, and sky. One of the formulas painters evolved, based on one-third sky to two-thirds land, is still useful in composing photographs. No one quite knows why, but the human eye finds that this proportion gives a harmonious, satisfying balance to most pictures. Whenever you break away from this classic formula, you probably—either consciously or unconsciously—intend to create a more emphatic picture.

▶ Putting the horizon two-thirds of the way up the picture gives a comfortable, but rather predictable, result.

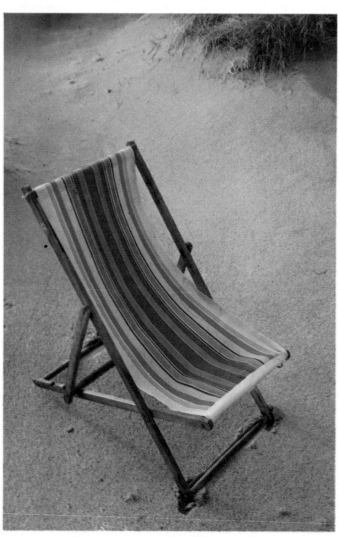

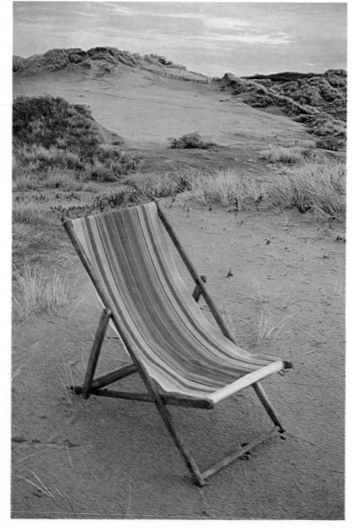

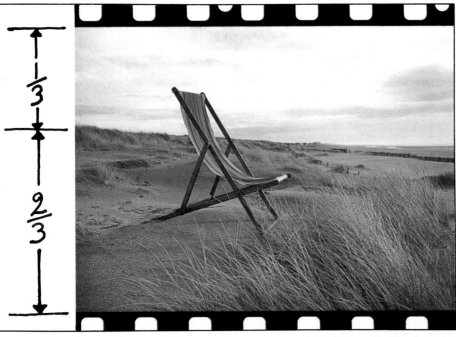

The four pictures at the bottom of the page show the effects of moving the horizon. From left to right:

With no horizon the subject is isolated and given prominence.

By moving the horizon lower the subject is placed in its setting.

The larger sky area is often dramatic, but this halfway split can be an uneasy compromise.

The low horizon makes full use of the sky's dramatic potential without detracting from the subject.

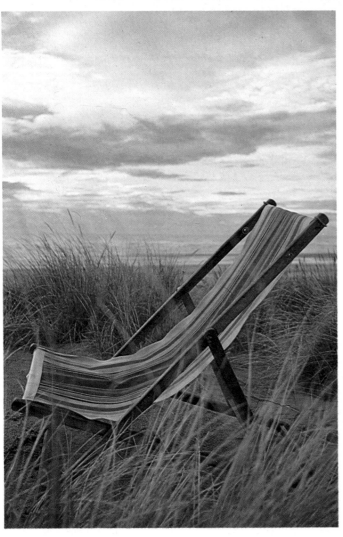

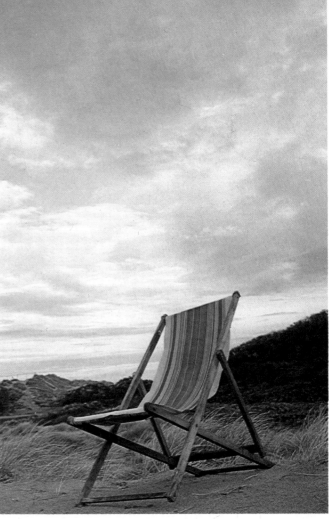

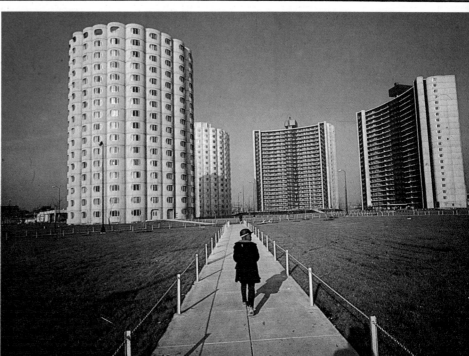

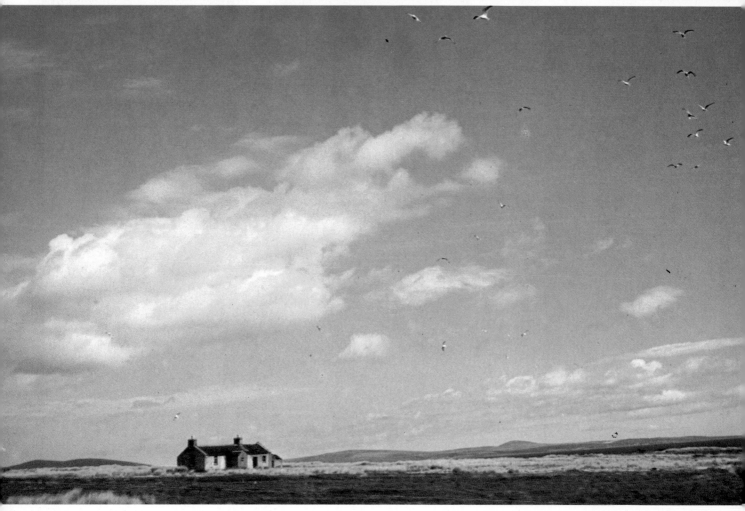

◄ Far left: central subject, classic horizon, but emphasis would differ with a lower horizon. *Spike Powell*

◄ The centrally placed horizon combines with bold vertical and horizontal lines to give balance to this urban landscape. *John Bulmer*

► Here foreground is the subject; the horizon simply acts as the end of the picture. *Barry Lewis*

▼ In this Orkney landscape the low horizon places the emphasis on the sky. The house is balanced by the cloud mass. *John Bulmer*

Using the background

Many people starting photography concentrate all their attention on the subject with hardly a thought for what is going on in the background. Yet the background can be of vital importance, and a cluttered or intrusive one could ruin a perfectly good picture. Equally, when the background adds something to the subject, it can lift a photograph out of the ordinary into something special.

There are three main points about the background to watch for: a) false attachments; b) competitive backgrounds; c) intrusive light or colour.

False attachments

These are the sort of unhappy effects where people appear to have lamp posts sprouting from their heads, or branches growing out of their ears. It is easy to miss this clumsy placing of subject and background when looking through the viewfinder. If you do notice it, try moving the camera position slightly until the 'attachment' separates from the subject.

Competitive backgrounds

These include the kind of general muddle that good planning may be

◄ The small shot at the bottom of the opposite page shows what can happen if the background is left to take care of itself—the girl disappears into the muddle and the photographer has inadvertently included his own reflection in the mirror. In the larger picture *Homer Sykes* moves the toymaker away from the messy part of the background and asks him to stand, so that his head is clear of the paraphernalia on the shelf.

► If you are working with a wide depth of field, look carefully at the background. Here the chimney coming out of the subject's head is typical of the false attachments hidden in many backgrounds. A slight sideways shift of camera position would have avoided this.

▼ Subjects with complicated patterns or shapes can easily become confused and merge into a patterned background. Put the wallpaper out of focus by using a wide aperture, and the flowers stand out from the background. Check the depth of field scale to make sure you have the area of sharpness you need.
Colin Barker

able to rearrange. If you cannot re-arrange the background, of course, you will have to move the subject if this is possible. But there are many cases where you cannot have this control over your subject—in candid photography or when you are photographing something immoveable like a statue or a building. In this case try altering the viewpoint, which may also help to sort out the tonal differences, such as when a statue seems to merge into the trees behind it instead of standing out.

Intrusive light or colour

These can also distract from the main subject. There might be a strong light source in the picture that draws your eye to it—and away from the main subject. Or maybe an area of strong colour, such as a bright curtain, dominates the picture when the subject of your photograph is wearing muted, delicate colours. Here again, the answer may be to move either the subject or the camera. Alternatively, if you have inter-changeable lenses, put the background out of focus by reducing the depth of field.

Aim to train yourself to notice these distractions in the background, whether it is muddle or that distracting red car in the distance which will register as a splash of colour just where you don't need it, *before* you take the picture. To handle backgrounds successfully so that they contribute to the overall effect of the photograph, consider them as part of the picture you are putting together in the viewfinder. The background should not be an after-thought, but part of the composition.

▼ The two pictures below show how an intrusive spot of colour in the background distracts the eye from the subject. Remove the splash of yellow and the eye goes straight to the subject. Although the background is intentionally out of focus, the spot of unsharp colour is enough to distract the eye from the statue. *Homer Sykes*

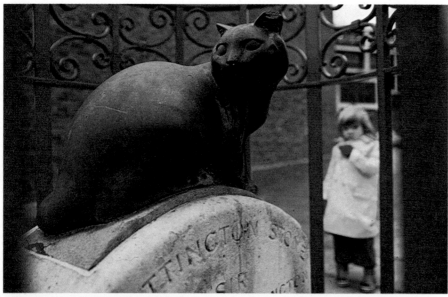

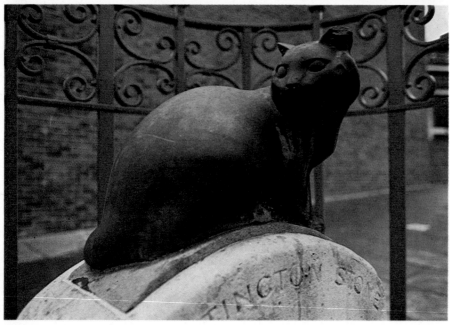

16

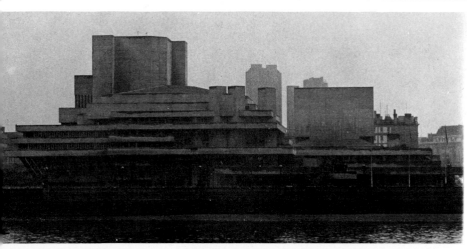

◀ The combination of a grey subject and poor lighting conditions means that the subject merges into the background. Contrast is too low to separate the buildings from the sky.

▼ As in the top picture, poor lighting has caused the subject to disappear into the background in this picture of the New York skyline. However, in the middle of the picture the sunlight has highlighted the buildings and lifted them out of the monotone of the background. *Tomas Sennett*

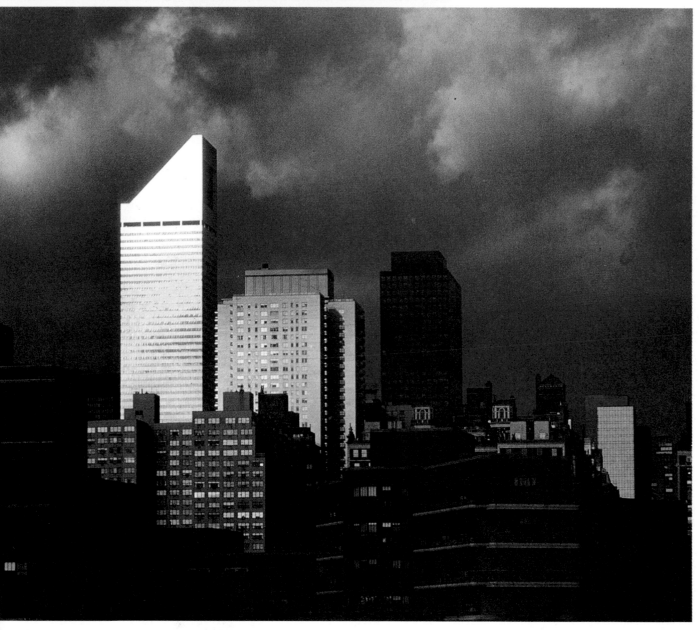

The foreground

It is all too easy to think carefully about the background before taking a picture, but leave the foreground to take care of itself. The result is often that distracting foreground objects seem to appear from nowhere and upset the balance of the picture. The photographer has to decide whether or not to include the foreground and, if so, how much of it. Many successful photographs have no foregrounds, but these are usually of subjects that are fairly close to the camera.

Using the foreground

Constructive use of the foreground is an important part of composition. It can add emphasis and balance, and tell more about the subject. If the perfect foreground for a picture is not immediately obvious, it may simply be a question of moving to a different viewpoint to include a wall or a hedge, or some shape close to the camera.

Foreground can also be used to give more information about the subject, especially when photographing people. This technique may range from including pots of plants and flowers in the foreground of a picture of a flower seller, to a heap of books in a picture of an author.

Creating depth

Use of foreground also introduces an impression of depth and scale to photographs. This is especially important in landscape photography, where foreground makes the picture start right at your feet, rather than away in the middle distance. If you include a ridge of grass at the front of the scene —before the eye gets to the sea and then to the distant fishing boat—you subconsciously relate one to the other and imagine distance and relative size.

▶ Not just any shopkeeper, but very definitely a sweet seller. Here the sharp foreground tells a story, and builds up the striking pattern of shapes and colours.
Patrick Thurston

▶ Far right: instead of choosing to point the camera at the distant hills, the photographer directed it down to include the foreground and emphasize the sense of distance. The extreme depth of field also contributes to this impression
Jon Gardey

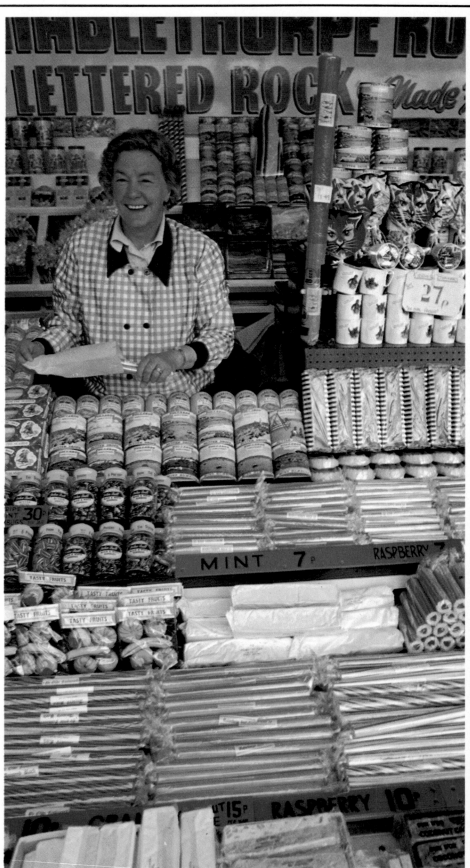

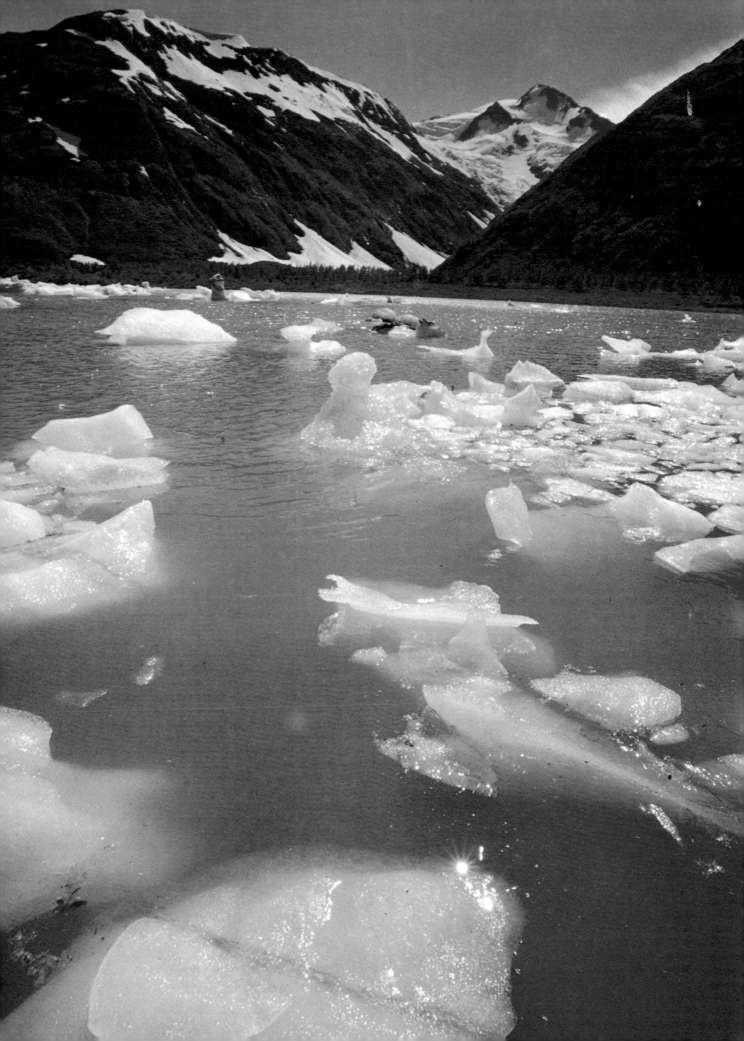

Framing with foreground

Foreground is not always confined to the bottom of the picture, but can form a complete or partial frame to your subject. A doorway, an arch or a window are obvious foreground frames. Outdoors, a branch or a pattern of leaves at the top of a picture may help to 'clothe' large expanses of uninteresting sky. Often these are more effective as silhouettes—just the shape with no detail or texture. Depth of field is no problem as this foreground treatment works well when the frame is partially, or wholly, out of focus. This prevents the foreground from dominating the picture.

Losing the foreground

There is always the danger that a prominent foreground will take over the picture and become distracting because objects close to the camera appear more defined—and larger—than distant objects. If you include a boat in the foreground of the photograph of the ice-filled lake on the previous page it might take over and become the subject. So always be quite clear in your own mind exactly what you are aiming to photograph.
There are three ways to 'lose' the foreground:
a) change camera position;
b) use a lens of longer focal length that takes in less of the subject;
c) reduce depth of field to put the foreground out of focus.
If something in the foreground threatens to become a distraction, you may choose to let it go out of focus by using a larger aperture, rather than leave it out of the picture altogether. But take care that it does not turn into a distracting blur. With many SLR cameras you can see the precise effect of foreground sharpness by using the depth of field preview button.

▶ Out-of-focus foliage in the foreground acts as a frame and adds colour. This device can be effective when photographing people, houses, and even views, when the subject might otherwise look isolated.
John Bulmer

▶ Centre: imagine this scene without the arch—just a dull expanse of stone. Archways, doorways, foliage all make simple but interesting frames to 'fill' the empty top of a picture.
Robin Laurance

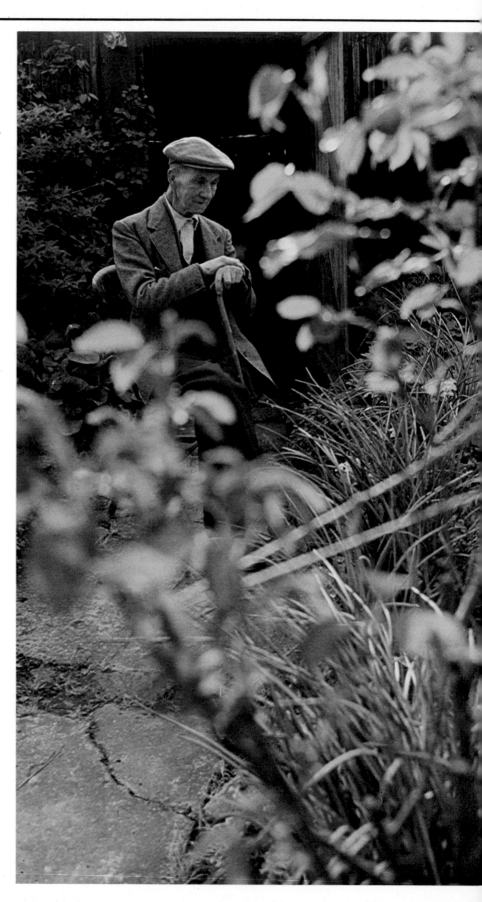

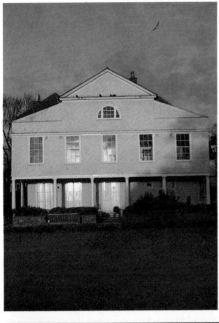
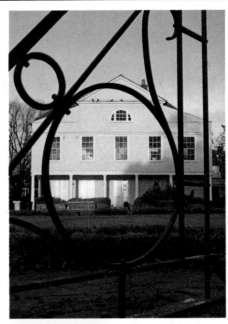
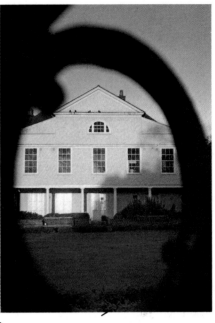

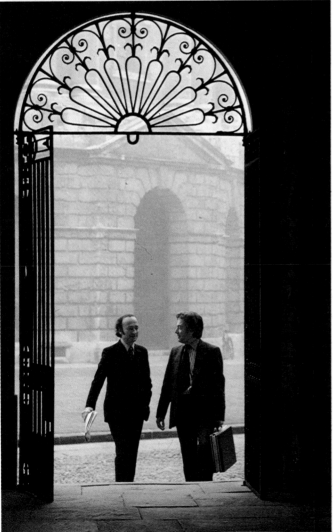

▲ Any clearly shaped object—a gate, a window frame, rigging on a boat—can be used to frame a view. Here, the house on its own looks rather bare and boring. In the central picture the gate becomes too distracting. On the right, the simple, slightly out of focus shape does not interfere with the view of the house.
Barry Lewis

▼ If the wall had been left out of this picture the scene would have been dominated by the stretch of grass in the foreground. Including the soft colours of the lichen-covered wall makes a more effective starting point for the picture without overwhelming the horse and the view. *John Bulmer*

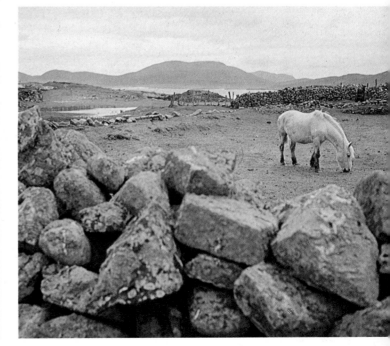

Where to put the subject

To many experienced photographers deciding where to put the subject in the viewfinder is instinctive. But for the beginner it needs as much attention as the horizon, the background or the foreground. Guidelines are useful for beginners, but you should soon start to let yourself react to the subject and not feel inhibited by rules.

The most obvious placing for the subject is in the centre of the frame: that way there is no danger of cutting off the tops of heads, or other important parts of the scene.

But a centrally placed subject often results in a dull picture. It also means that the photographer may not be filling the frame enough, with the all-too-common result that the subject is too small in the final print and becomes absorbed in a background which adds little to the picture.

However, a centrally placed subject can work particularly well when the picture has strong geometric lines that the photographer wants to capture. This can be especially true when photographing architecture where the geometric balance is important.

Most people find they prefer to look at a point just above the geometric centre, so consider positioning the most important part of the subject just above mid-centre. Then see the effect of moving this part to the geometric centre, to the top half of the picture and then below, and see which is most effective for the particular subject.

▼ The middle of the frame is often the most satisfactory place for a round subject. Here, background would be a distraction from the minute, precise detail. *Eric Crichton*

▶ A strongly geometric composition: oblong door, triangular ladder and the man dead centre, with just the position of his hand and swinging foot to add a touch of vitality. *Martin Parr*

▲ Putting the subject dead centre tends to make it static, while moving it a bit to one side gives the whole picture a more dynamic sense of movement. *Robert Estall*

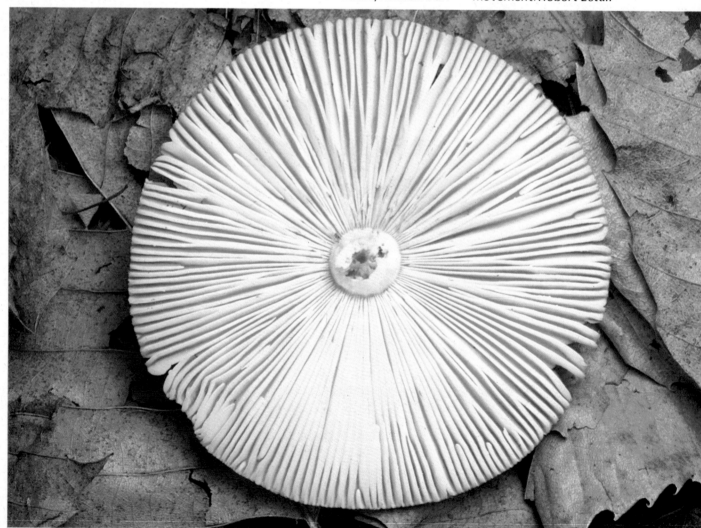

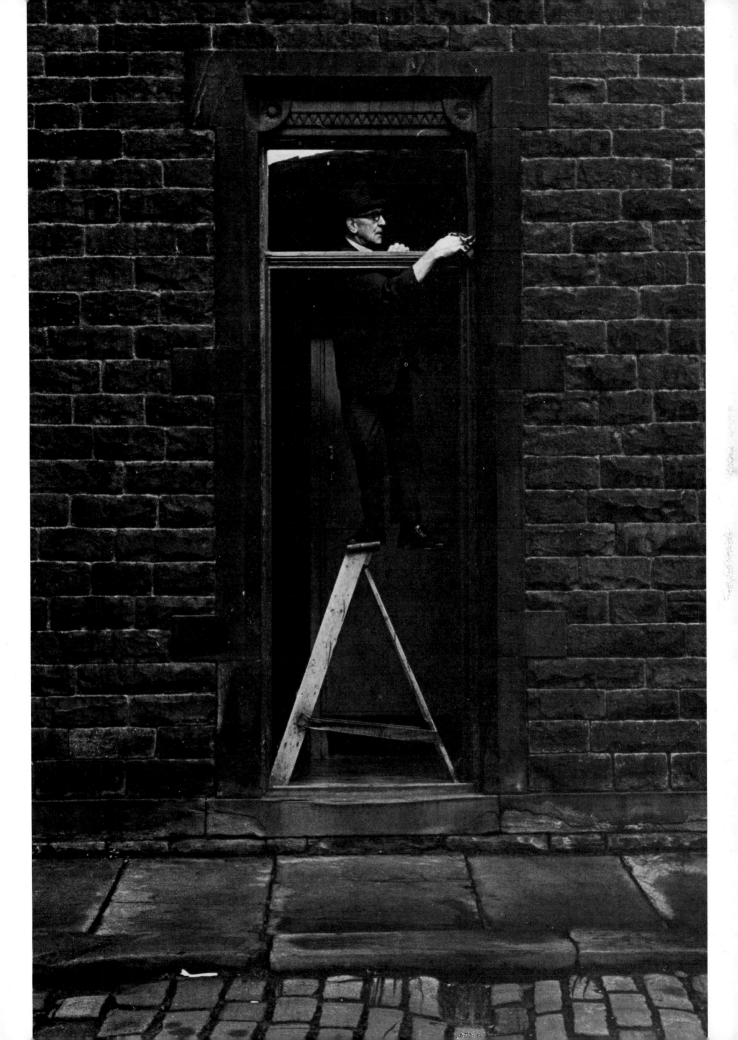

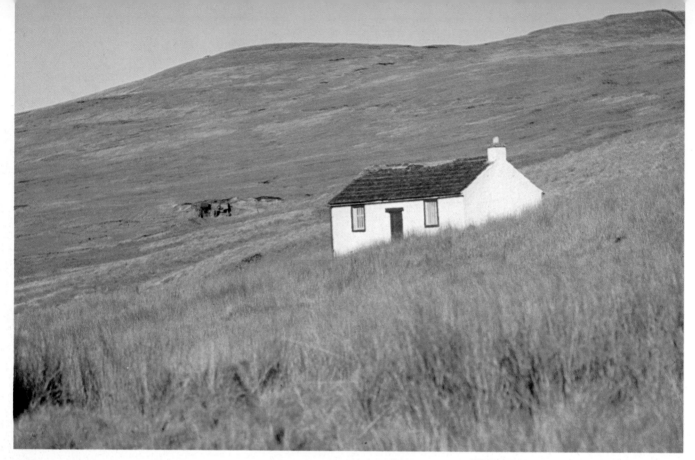

The intersection of thirds

The traditional way to produce a balanced, satisfying composition is to use the 'intersection of the thirds'. Painters have used this formula for centuries and some photographers find it helpful too. But take care not to apply this rule rigidly to every picture or you will soon find the results boring and repetitive.

If you have a subject such as a tree, or a person, or a chair, start by positioning it on one of the two vertical third lines. This position often gives a more satisfactory composition than a central one. (Compare this with the section on where to put the horizon.)

Next, imagine that the scene is divided into thirds, both horizontally and vertically. The intersection of the thirds produces four 'ideal' points on which to position the subject.

▲ All the photographs on these pages are balanced differently to suit either the shape or mood of the particular subjects. Landscapes are the easiest subjects to experiment with because they do not move. This cottage is shown positioned on a vertical third : now consider how the picture would look with the cottage a little higher, or lower, positioned on one of the intersections. *John Bulmer*

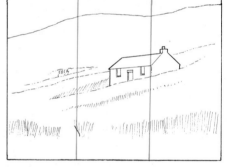

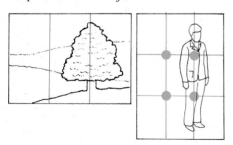

**Above left : a diagram showing the positions of the vertical thirds.
Above right : a diagram showing the four 'intersections of thirds'.**

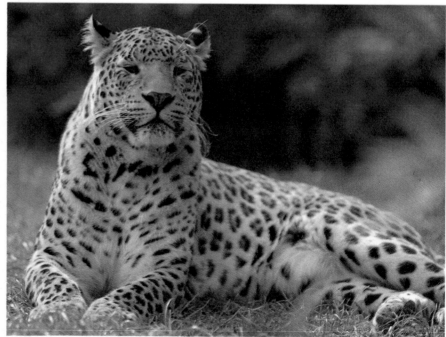

► When you are arranging the picture in the viewfinder try altering the camera position. The photographer used the strong rectangular shape of the window to dominate the picture, and the placing of the head—to which the eye is immediately drawn—is balanced by the bench at the bottom of the picture. With a still subject take more than one picture and try arranging the composition differently. *Bryn Campbell*

◄ With a subject like a wild cat it is less easy to move the camera. Here, the head and shoulders of the animal dominate the composition. A lower placing of the head would have meant cutting off the bottom of the body—making a weaker picture. *Eric Stoye*

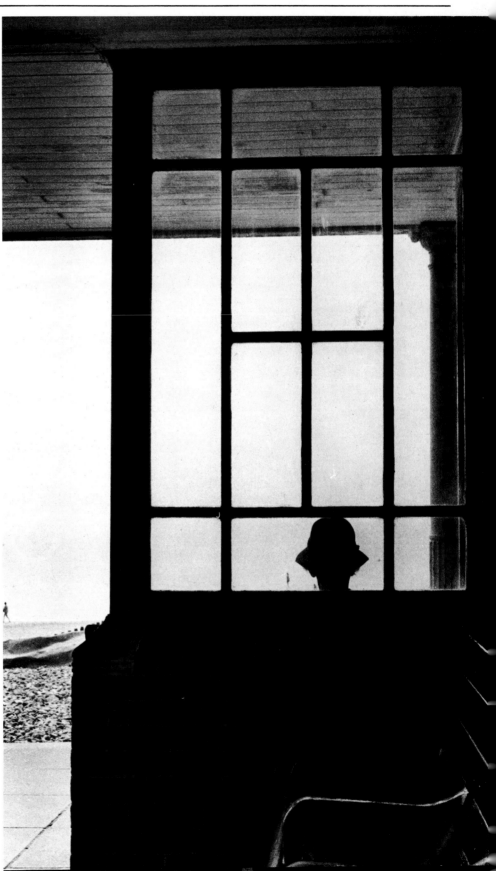

Emphatic alternatives

Placing a subject off-centre in any direction is one of the many ways of creating emphasis in a photograph, making the eye go straight to the subject. At first glance the family group by Tomas Sennett (far right) might seem unbalanced, with the figures squashed right over to the side of the frame. But in fact the group is carefully balanced by the expanse of sea, which also places them in their seaboard surroundings.

Similarly, Roland Michaud's picture of the Tibetan monk—placed firmly to one side of the frame—is a satisfying, well-balanced composition because the face is looking *into* the picture. By closing in on the head, the photographer leaves no doubt where the centre of interest lies.

If you place a subject off centre, what happens to the 'space' created? In many cases, like the two pictures just mentioned, the space becomes a balancing factor in the composition. The photographer can also use the space to add information about the subject.

Room to move

But there is another important reason for not composing certain pictures too tightly. A moving subject seldom looks right if placed in the middle of the frame. Patrick Ward's picture of the man on the bicycle needs the space on the right of the frame. It is not only a question of balance but also that a moving subject needs space to 'move into'. This is especially worth remembering in sports photography, although often difficult to achieve as all one's attention is on the action.

Another effect of leaving plenty of space around the subject is to emphasize loneliness or isolation. Here the space around the subject is as vital as the subject itself. The photograph of the tractor ploughing would have been less effective if it had been taken close to—the space emphasizes the scale of the open landscape.

Try it another way

All this is not to say that every subject should be placed off-centre. The important thing is to try various alternatives before taking the picture. If you can't move the subject move the camera and, if there is time, take more than one picture, varying the camera viewpoint to change the placing of the subject. If you can't move yourself or the subject but can change lenses to alter the angle of view, try using a lens of different focal length.

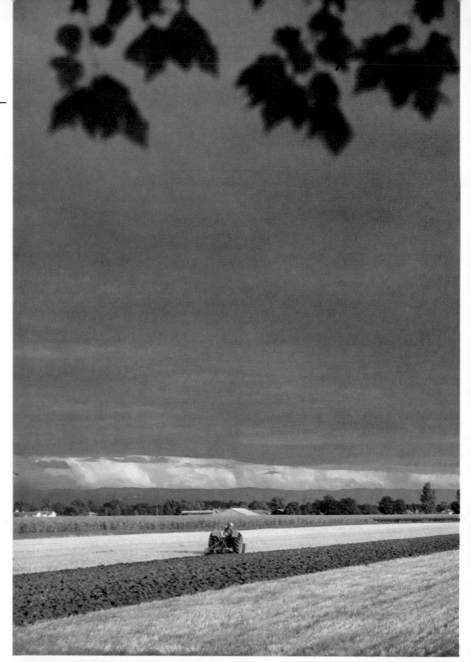

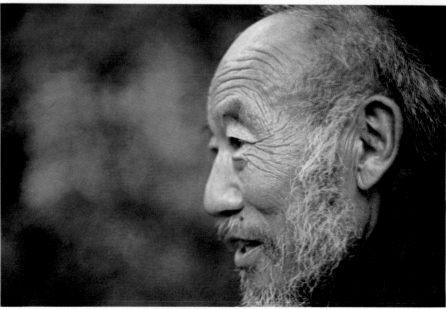

Emphasis is a way of making people notice a picture they might otherwise not have looked at. There are various ways of achieving this—by the way the picture is composed or by the way shapes, pattern and colour are used. Where the subject is placed is one of the most obvious ways of drawing attention to it. All the photographs on these two pages seem to break the obvious rules—but all succeed in holding our attention.

◄ Emphasizing the sense of wide-open space with a vast sky.

◄ Emphasizing the monk's gaze by leaving space in front of him.

► Emphasizing the importance of the sea in these people's lives.

▼ Emphasizing movement by leaving space for the bicycle to 'move into'.

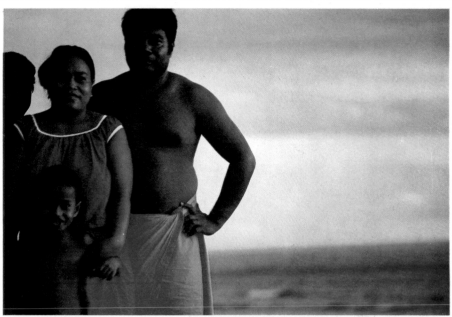

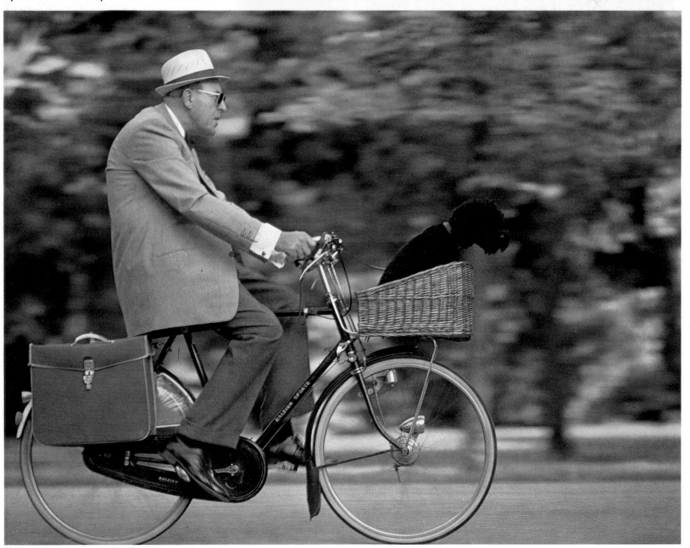

The edges of the picture

Once he has decided where to place the subject, the photographer must plan how the contents of the picture will relate to the edges of the frame. This involves more than just glancing at the edges of the picture in the viewfinder to make sure the picture is correctly framed. It is a common mistake to cut off the heads or feet of people you are photographing and this is often the result of having to take the picture too quickly, or being too close to the subject. But apart from such elementary mistakes, how should you decide where to crop the picture in the viewfinder?

A good way to discover the different ways of cropping a picture is to use a pair of right-angled strips of card when looking at pictures. Place them over a print and vary the borders of the composition. To re-create the same effect in the camera, move the camera closer or further away from the subject. The best way to test this method is to choose a static subject such as a landscape or a building, where you can easily assess the merits of adding or removing parts of the picture. Always bear in mind that the simpler the picture, the more likely it is to be strong and effective.

Looking at the same picture cropped in three different ways shows that this is another way of giving emphasis to the subject. A very tight cropping round a portrait will concentrate the eye on the face, or even part of the face, and can strengthen a weak or uninteresting picture. It is a way of leading the eye straight to the essential point the photographer was trying to make, or of excluding confusing foreground or background detail to make the photograph more explicit and clearcut.

Use the edges

There is no hard and fast rule of composition which says that the edge of the frame must not 'cut' into your subject, and often a detail from what you are photographing can be as strong a way of portraying it as showing the entire subject. As in placing the subject, it is a question of the emphasis you want to achieve. But there are dangers in going in too close on some subjects. For example, a building may look uncomfortable close to; move back and allow a little more space around the edges and it looks better. Move back further and the distracting elements on either side begin to compete with the subject so the picture ends up with no clear centre of interest.

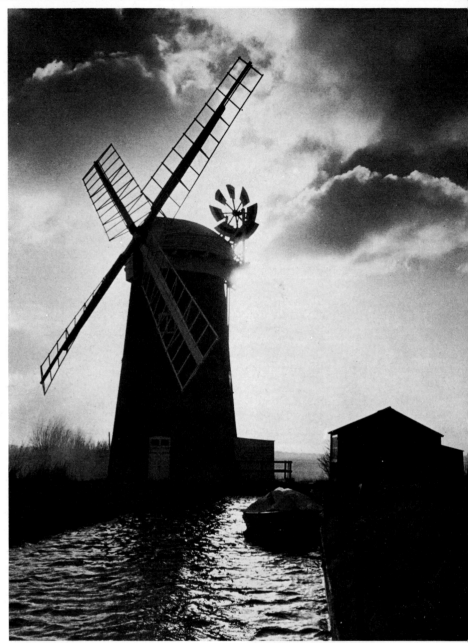

AT THE TOP
Cutting off someone's head is an obvious error—but cutting off the top of a building can be equally unfortunate. The picture on the right shows a windmill taken so close in that the top sail is cut off. Now compare it with the picture above which completes the shape, giving 'breathing space' to the mill and including just enough of the canal in front and the shed on the right to balance the weight of the building. Think of the same points when photographing any building—be it a church, a factory or a skyscraper.
Bill Coleman

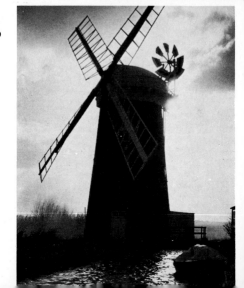

28

▲ If you are going to cut into a subject, it is often more effective to do so emphatically. *Tomas Sennett* used a telephoto lens to avoid distortion and yet get close enough to the subject for the effect he wanted.

▲ Ask yourself *what* you really want to emphasize. Here *William Wise* homes in on the children : if he had included the father full length the children would have become less significant instead of being the subjects.

▼ Obviously *Thomas Höpker* was amused by the way each lifeguard is standing with his hands held the same way (except for the one on the right). Cutting off the heads intentionally draws attention to the point.

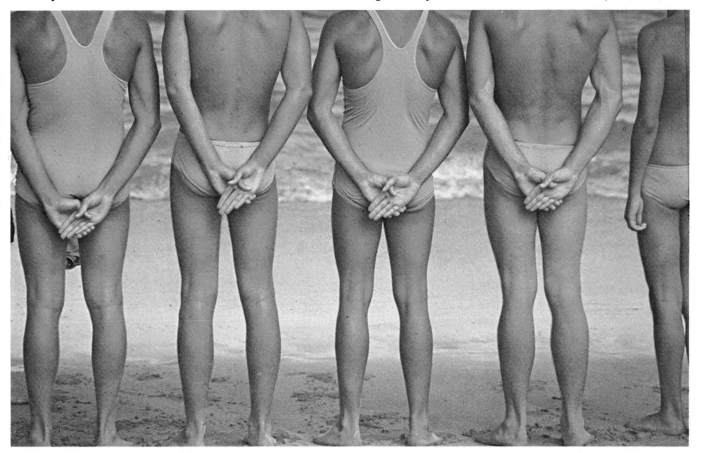

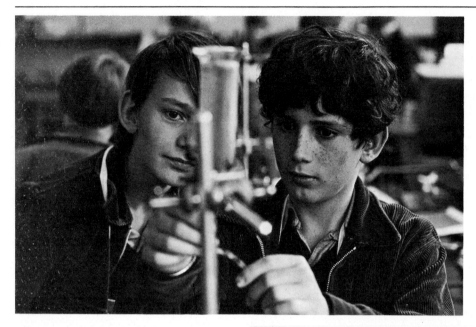

CHANGING THE MEANING
Cropping excludes distracting detail, but it can also produce a misleading picture. The boy looks in a day-dream in the close-up view: in context, he is actually absorbed in an experiment.

Making a point

How the photographer crops the picture can alter the meaning or make the picture accentuate a different point. A close crop round the face of the boy shows simply that—a boy's face, out of any context—whereas the longer view places the subject in his appropriate surroundings, at work in a school laboratory, absorbed in an experiment. So the emphasis of the picture is changed from a straightforward portrait to one which tells more of a story.

SIDES OF THE PICTURE
One of the hardest decisions is how much to leave in at the sides. The maxim 'when in doubt, leave it out' doesn't always apply, as in this picture of two sailing barges. The bank on the right tells you clearly that this is a river, not a sea, view.

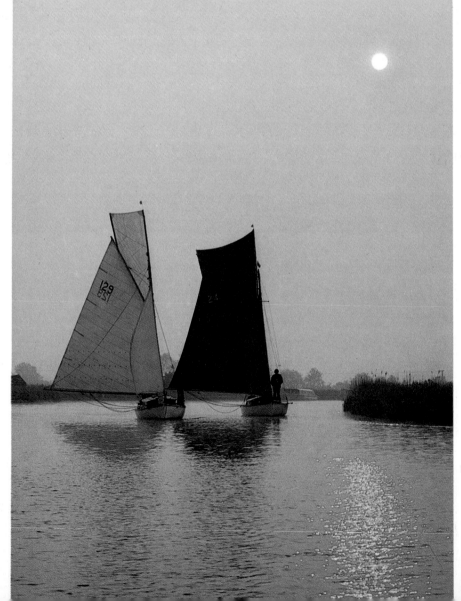

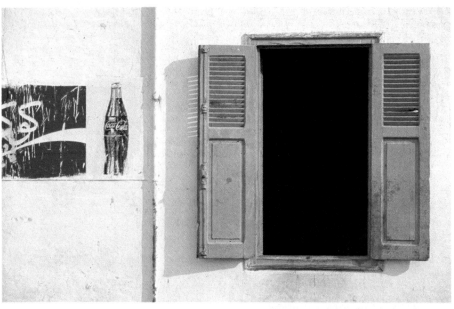

LOOK AT THE EDGES
Once again, it all depends on what you want to emphasize. The small picture above shows a dusty Arab street corner where the viewer hardly knows whether to focus on the Coca Cola ad, the window or the figure round the corner. Next *Michael Busselle* decided to leave out the figure and dwell on the pattern, colour and East-meets-West juxtaposition.

Emphasis in printing

It takes practice, luck, experience or an intuitive eye to master the various possibilities of composition when the picture is taken. But if you get it wrong at this stage the balance or emphasis of your photographs can sometimes be improved at the enlarging stage. Some photographers prefer not to interfere with the picture at this stage, feeling that the way it was 'seen' at the moment it was taken is all important. But for the beginner it gives the chance to experiment and vary the balance of a composition. If you don't do your own printing, simply mark the area you wish to be printed on the enprint and tell the printer what size you would like it blown up to.

Cropping the finished print

Alternatively, the finished picture can be cropped by trimming. For example, a picture in which the subject is long and thin benefits from being trimmed to this shape. Look at finished pictures and see how often they can be improved by more imaginative cropping—often simply removing a disturbing background. A photograph does not have to fit the exact rectangle of the manufacturer's paper size any more than the subject must sit in the middle of the picture for good composition.

LOOK AT THE BOTTOM
Take a sheet of paper and slide it up the photograph of the two men. How do the figures look with their feet cut off; cut off at the knees, or just below jacket level?

Choosing your viewpoint

Your choice of viewpoint, or camera position can make or break a picture, yet many people hardly give it a thought. The viewpoint has the greatest single influence on the picture. If you were going to hang a picture on your wall you would first examine the room carefully, looking for the position which would best complement both the room and the picture. The same amount of consideration should be given to taking a photograph. Just as you wouldn't dream of hanging your picture on the first spot on the wall that happened to catch your eye, so the best viewpoint is unlikely to be the first place from which you saw the subject.

Explore the subject

There are some occasions when the most immediately obvious viewpoint is the best possible place from which to take a picture. Generally this is not so, however, and the first thing you should do after deciding to take a photograph is literally to walk around the subject. See how it looks from the left and right, farther and closer, higher and lower.

You should in fact learn to explore your subject, to 'see' the full picture possibilities.

It is a very useful exercise to photograph a suitable subject from every conceivable viewpoint. You will be surprised just how much variety of composition and emphasis can be obtained from even the most basic situation or subject.

Lighting

It is important to remember that the camera position affects not only the

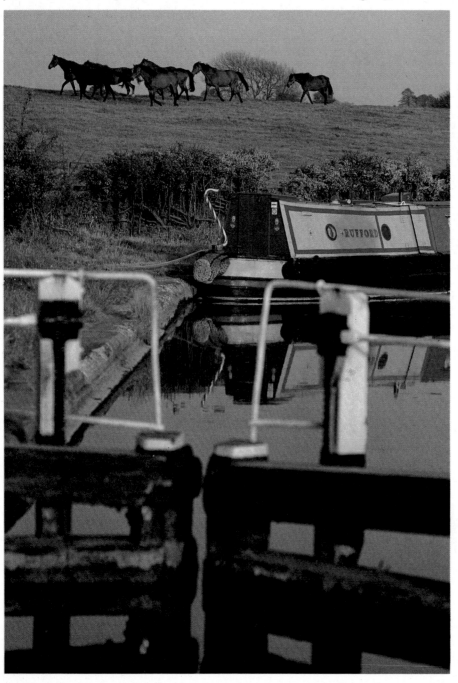

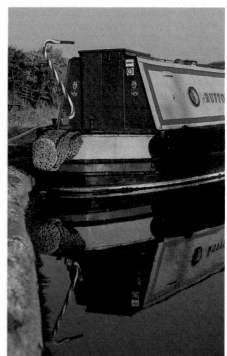

▲ The advantage of a close viewpoint is that the composition can be reduced to essentials, usually resulting in a simple design. Because it is simple, however, the smallest detail plays an important part in the picture and so must be carefully considered. For this picture *Patrick Thurston* positioned himself very precisely so that the tiller just appears in the sky area above the bank, while the reflection just misses being cut into by the edge of the pathway.

◄ A very different picture is created by moving to a more distant viewpoint. The barge is seen in its setting and there are more points of interest. The height of the camera is important here as it controls the overlap between the foreground, subject and background. Any lower and the lock gates, barge and field would have been mixed up.

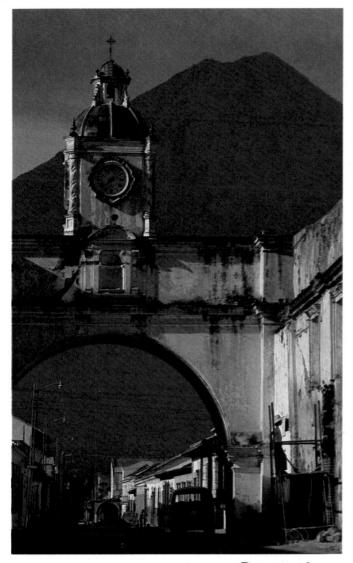
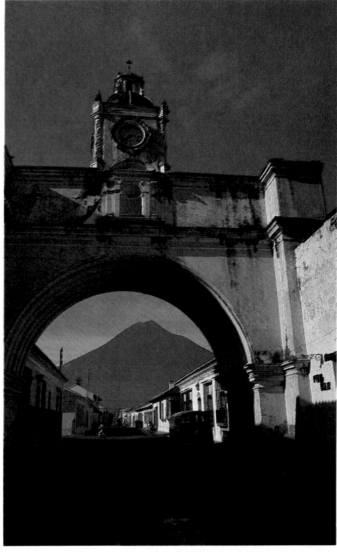

composition of the image but in most cases also the lighting.

Study the effect of the light on your subject and see how the lighting quality can be changed simply by moving the camera. A good example of this is the difference that shooting a subject against the light can make to the image, as opposed to conventional over–the–photographer's–shoulder lighting. Or you may need to move the camera so that part of the subject hides the sun to prevent flare.

Where the texture of a subject is important in a picture the direction of the lighting is a crucial factor. In this instance a shot head–on to the subject will rarely make the most of the texture, while shooting into the light would destroy detail completely. It is important, therefore, to look at the effect of the lighting when choosing your viewpoint.

Perspective

Another aspect of photography which depends totally on viewpoint is the effect of perspective. By changing viewpoint you change the relationship between the size and proportion of the various elements in the picture area.

You can learn a great deal about perspective simply by observing what happens to the apparent sizes of objects as you move closer or farther away from your subject. Take a person standing in front of a building as an example. From a distance the figure is overshadowed by the prominence of the building. As you move closer, however, the figure becomes proportionately more dominant and the prominence of the building is diminished.

Generally speaking a low, close viewpoint will exaggerate perspective, while a distant viewpoint will lessen it.

▲ A new viewpoint combined with a change of lens can make a spectacular difference to perspective and scale. For the picture on the left *Anne Conway* used a 135mm lens. By moving about 30 metres closer and changing to a 28mm lens the archway appears to grow and now dominates the volcano.

Changing lenses

To be able to change the focal length of your lens is a considerable advantage when choosing your viewpoint. Indeed, changing lenses will often encourage you to change your viewpoint. A longer lens, for example, enables you to use a more distant camera position but still obtain an image of adequate size. With a portrait, for instance, the perspective effect on a face is very unflattering when a standard lens is used closer than about 1·5 metres. A longer lens enables you

to shoot at twice that distance and still get an image that fills the viewfinder, but without the apparent distortion.

A wide angle lens (shorter than normal focal length) enables you to include more of a scene without having to move farther away. This is a particular advantage when taking pictures in a confined space, and it also enables objects quite close to the camera to be included in the foreground. This can also be useful in landscape photography to produce an impression of depth and distance.

One of the unexpected bonuses of using a lens of a different focal length is that it encourages you to take a new look at your subjects and to try some new viewpoints.

Framing

Finally, having decided on a general position for your camera, you should consider *slight* changes of viewpoint. Maybe one step to the left to exclude an intrusive colour, or a fraction lower so that you include an interesting piece of foreground, will make all the difference to the final result.

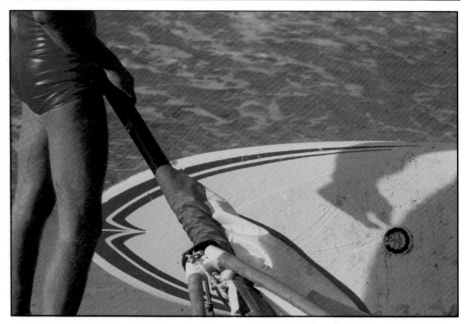

▲ *Tessa Harris* has used a very close viewpoint to emphasize the graphic quality of the strong colours and shapes of this windsurfer as he dismantles his craft on the beach.

▼ When the figure moved the shapes became much simpler, so Tessa lowered her viewpoint very slightly to include waves rolling into the beach as a more interesting background.

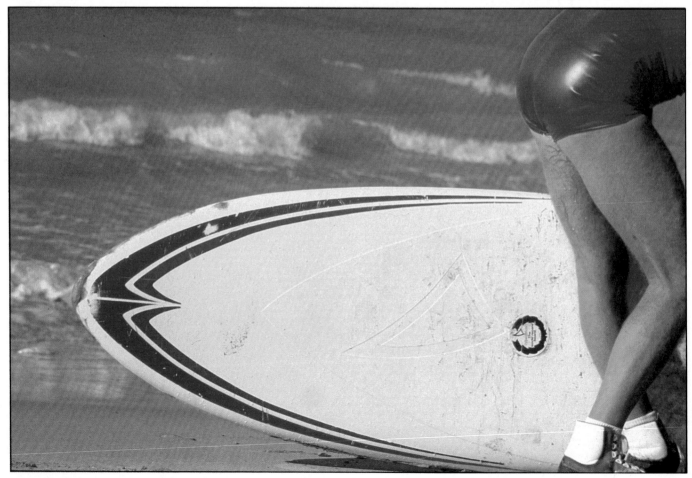

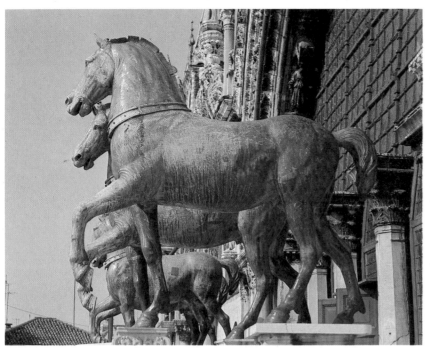

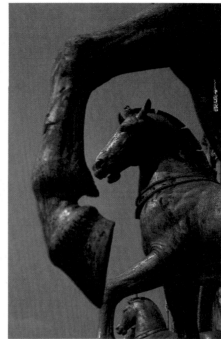

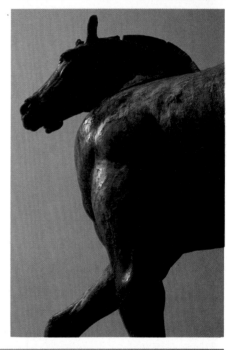

Write a check list

Ask yourself when was the last time you took a picture from ground level? Or from the top of a building? Or even from a chair? When was the last time you focused your camera at less than three metres? It is surprising how easily one can lapse into a routine and forget to explore the full possibilities of a subject.

You might even consider writing yourself a check list of possible viewpoints:

● From left and right
● From behind
● From a high viewpoint
● From close up
● From far off
● Including foreground interest
● Using a foreground object to frame the subject
● Directly into the light
● Lying on the ground, either facing forwards or on your back
● Directly above the subject.

These pictures were all taken from the balcony of St Mark's Basilica in Venice. They show how by careful choice of viewpoint the photographer can control exactly what is included in the picture, and in this way place personal interpretation on the subject. For the picture above left *Van Phillips* chose a viewpoint which accurately reflects what the horses look like. But with the other four shots, *Malcolm Crowthers* was trying to convey the sentiments of Petrarch, for whom these horses seemed 'to neigh and paw the ground with their hooves'. For the picture below left he actually lay on his back, hanging over the balcony slightly, to capture the descending hoof. The lifelike impression is helped by the fact that from this viewpoint all reference to the building is excluded.

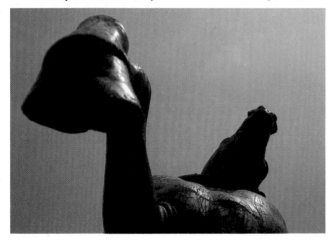

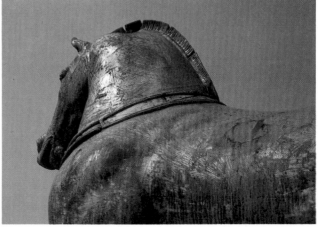

Judging the moment

Photography has one unique advantage over other visual arts: it can record an occasion or event at the instant it takes place. Having said that, it is essential to remember that unless you have a cine camera you will not be able to capture every moment of an action, nor are the circumstances ever likely to occur in precisely the same way again.

Because of this, the moment at which you release the shutter is of vital importance. The split second decision which a photographer makes when he presses the shutter release is the crucial factor in the vast majority of great pictures. Henri Cartier–Bresson has described it as 'The Decisive Moment', and it can exist as effectively in a landscape picture or a portrait as it can in a dramatic sports photograph.

Reacting quickly

Judging the right moment to take a photograph is largely based on an awareness of the elements in the composition which are affected by the passage of time. For shots of people these are fairly obvious, and the best time will usually be at the height of the action in a sports shot, for example, or when the subject reacts with a spontaneous expression for a portrait.

Other subjects are more difficult. A landscape, for example, may appear static, but if you look carefully you will see that it is in fact constantly changing. The position of the clouds, for instance, will change and this in turn will affect the quality of the light. The time of day will also affect the colour and strength of the light, and the time of year will alter the basic appearance of the landscape. More obviously, at one moment it may be possible to include a flying bird in your composition, or a passing car or figure, or the wind might change direction and alter the shape of the trees.

Most of these elements are only transitory but they can make an important difference to your pictures. Watch carefully for them and take advantage of them immediately they appear. You may never get a second chance.

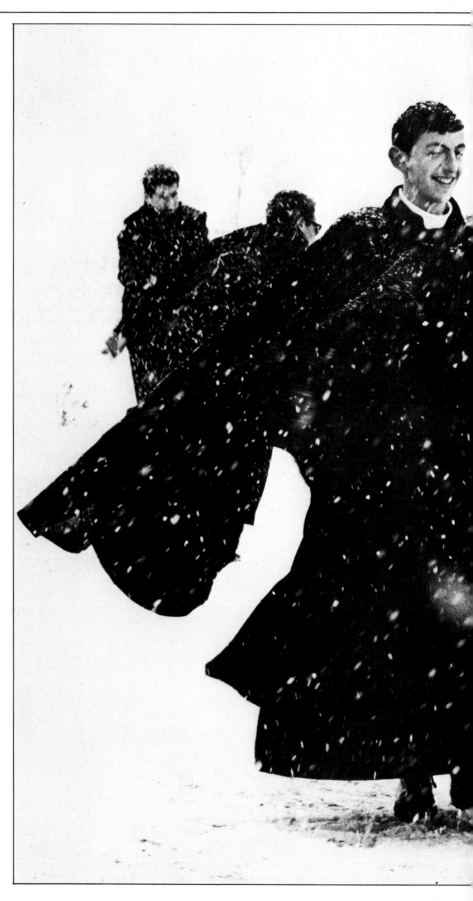

▶ **One of the many interesting aspects of this picture is the incongruity of the scene—monks playing in the snow.** *Mario Giacomelli* **caught the peak moment of the action precisely, captured in the strong graphic shapes of the whirling cloaks. In rapidly changing situations like this it is best to take several shots and choose the best composition afterwards.**

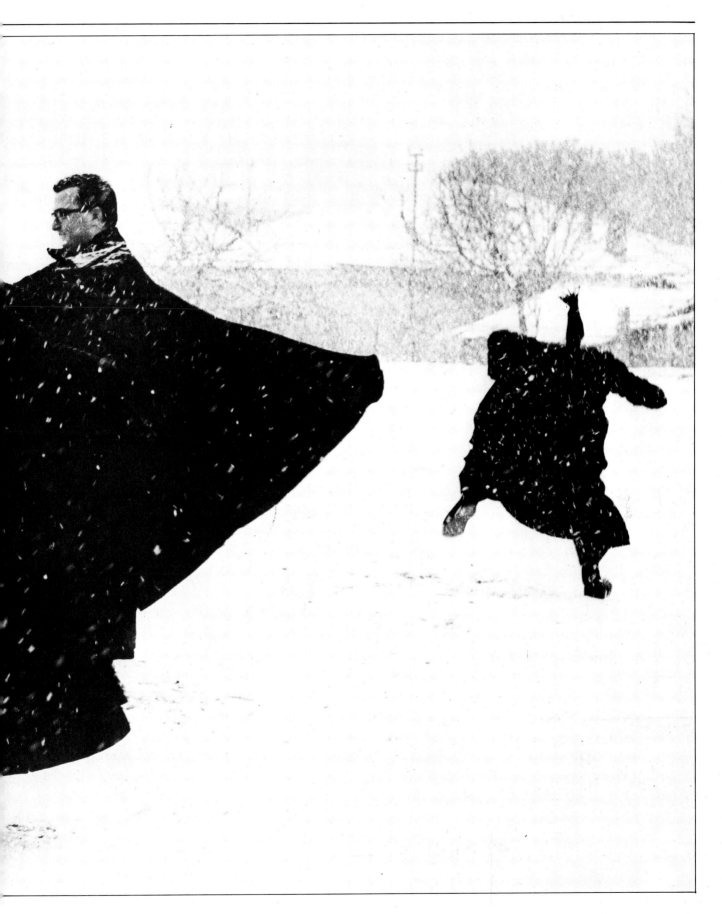

Anticipation

The number of occasions on which the perfect composition presents itself immediately are rare. More usually a situation has the potential for making a good picture but the elements have not quite come together—something is lacking. This is the time to wait and see what develops, rather than take a hasty, not quite perfect picture.

A sunset, for example, is often most spectacular a few seconds before the sun disappears below the horizon. If you have the time it is worthwhile waiting for five minutes for this moment—and be prepared to take a few shots.

Alternatively, your composition could perhaps be improved by the inclusion of a figure to give the rest of the scene a sense of scale. In that case wait for a passer–by. Don't, however, take the picture the instant the figure appears. While waiting you will have had time to work out the best position for a figure to be in. Wait until he gets there, and then take the photograph.

Once you become aware of this 'coming together' of elements you can begin to anticipate a good picture. Sometimes you can even have the impression that you are controlling things like clouds and distant people and willing them, successfully, to do what you want.

Sports and action shots

Anticipation is a key factor in the precise timing of exposures for sports and action photography. It is rather like driving a car. If you watch the road, other cars and pedestrians and become aware of their possible movements, you won't be caught off guard if you suddenly need to make an emergency stop. Action shots require the same sort of anticipation.

You would need almost superhuman reactions to capture the peak moment

► An unexpected moment of levity at a formal dinner. Quick reactions rewarded *David Hurn* with this shot.

▼ A good photograph often has to be anticipated. For this shot *Bruno Barbey* first composed the picture leaving a space for a figure to walk into. He then waited. When the right kind of person came along he had the picture he was after. Only then did he release the shutter.

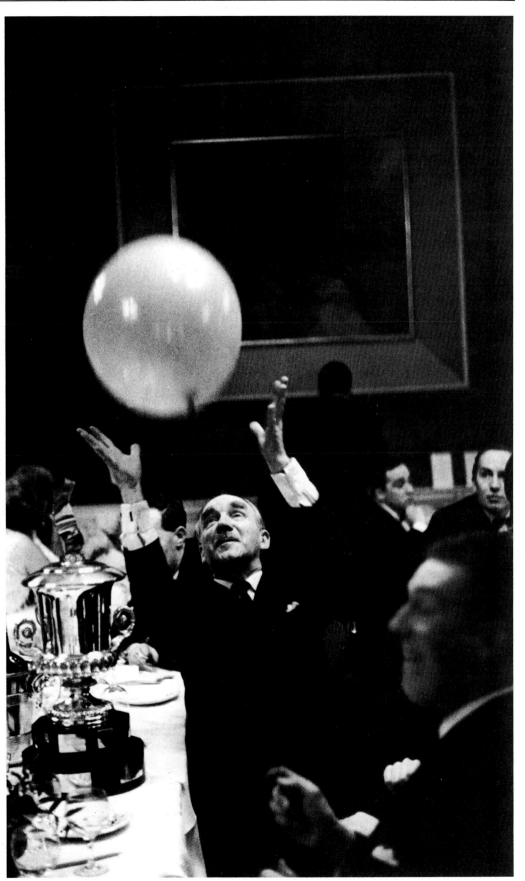

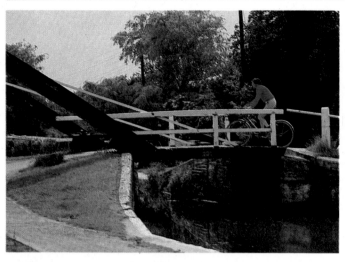 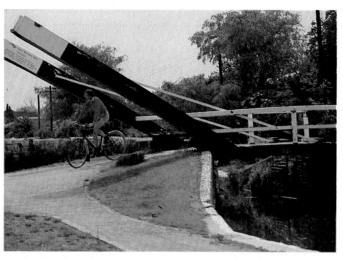

▲ When a composition includes a moving subject like this man on his bicycle it can look unbalanced if the movement leads the eye away from the picture (right) rather than into it (left). A little forethought about basic composition like this can help when it comes to making a decision about when to release the shutter. *Michael Busselle*

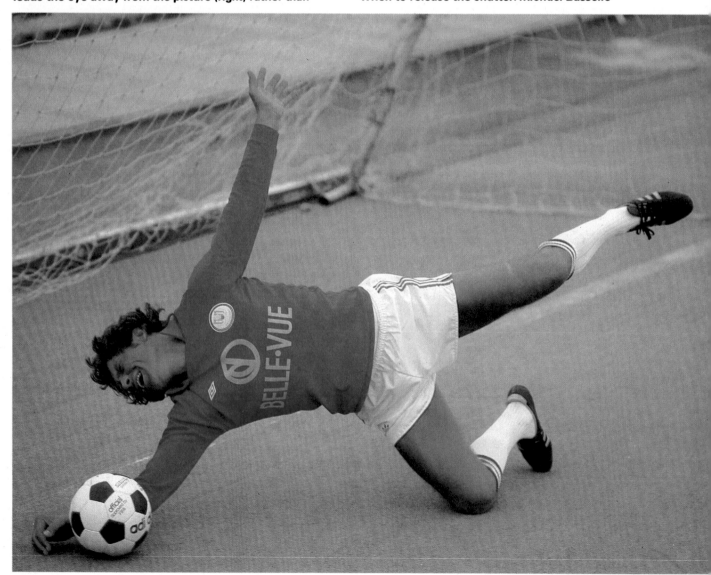

of a sports action without having followed the preceding sequence of movements. By watching carefully, however, you should be able to anticipate the precise moment that the action reaches its climax. Even a motor–driven camera at five frames per second can miss this crucial moment, but the photographer who has followed the action and knows his equipment should be able to capture it almost every time.

Taking more than one frame

Professional photographers often shoot many rolls of film of one subject. Less charitable amateurs believe that this is to ensure that at least one frame 'comes off'. There may be a grain of truth in this, but for the most part the practice is based on rather more practical reasons.

To earn his living the professional has to be sure of getting the best, and even with perfect anticipation of a particular moment he can't guarantee that something unexpected will not happen a little later. So he carries on shooting. Although an amateur may not be able to afford quite the same generosity with film he can still apply this principle to a more limited extent. Don't put your camera away having taken just one exposure—be ready for the unexpected. Shoot as much film as you feel you can reasonably afford, and pick out the best shot later.

Controlling the camera

There is nothing more frustrating than to be presented with the perfect picture and then to find that by the time you have wound on the film, focused and set the aperture and shutter speed the scene has changed and the picture is no longer there.

Adeptness at handling the camera controls is, therefore, another vital element of judging the moment. Practise without a film in your camera until handling the controls becomes second nature. Then, when the right moment comes you will be ready to make the most of it.

◀ Capturing the climax of an action in sports photography depends to a great extent on anticipation and following each sequence of events carefully. But ability to use the camera controls well and quickly is equally important. Fast focusing especially is an essential requirement. A picture like this one by *Tony Duffy* would be useless if the goalie was out of focus.

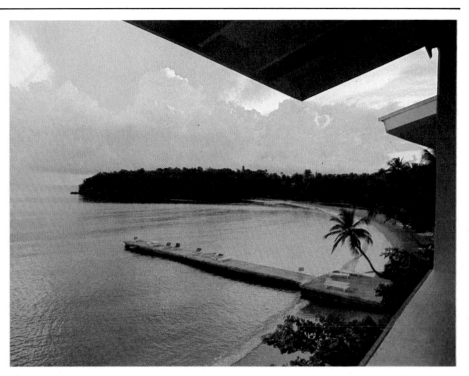

A good landscape photograph, or in this case a seascape, can rely on the moment at which it was taken almost as much as an action shot. Timing is not quite so critical in terms of seconds or minutes, but the time of day will certainly have a considerable influence. These two pictures (above and below) were both taken from the same hotel balcony in Jamaica. The one above was taken at about 5 o'clock in the morning and the one below 6 hours later. **Although the basic picture remains the same the detail is revealed by the changed direction and intensity of the light. Early morning light produces a pale, moody picture with no detail in the trees or on the pier. Towards midday colour and detail can be clearly seen in both. To see the way light changes throughout the day try shooting the same scene at three hourly intervals from dawn to dusk.**

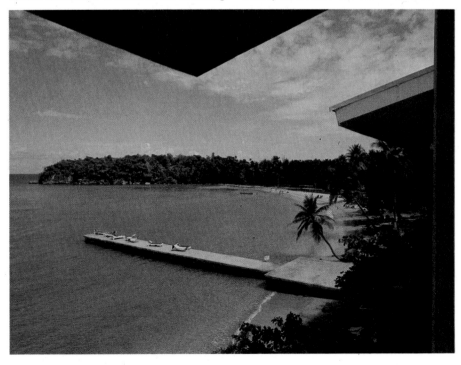

Images in silhouette

A silhouette is the most elementary form that an image can take; in the true sense it is simply a black shape on a white background and the only interest it has is the outline of the shape itself. Yet silhouettes can tell a story in which the viewer mentally fills in the details. For example, the cut-out profiles which were popular in Victorian times often conveyed a strong likeness of the subject and revealed more than a little character.

Looking for silhouetted images is a good way to learn the basics of composition because the simple outline shows clearly how shapes within a frame balance each other.

Shape alone is enough to identify some things, while others need more elements to be recognizable; the silhouette of a banana, for example, would be enough to identify it, while the rounded outline of an orange would be less easy to recognize.

How to use silhouettes

A pure silhouette is rarely used in photography. There is usually a sug-gestion of other details included in the image, a little colour or tone, a suggestion of form or texture, or just some detail in the background. But the purpose of such an image remains the same—to concentrate the viewer's attention on the shape or outline of the subject. A silhouette showing subdued details, rather than one where the detail is completely blacked out, is an effective way of doing this. By using semi-silhouette conditions, something is left to the imagination and this in itself can bring a suggestion of mystery.

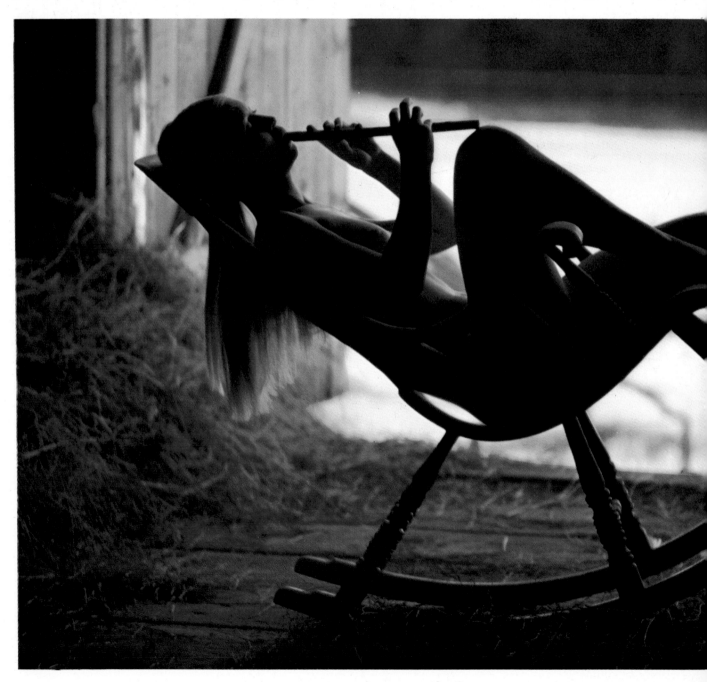

How to create silhouettes

Silhouettes can be created in several ways: you can use natural or artificial light, shoot into the sun, use foggy or misty conditions.

Natural lighting indoors: you can use controlled lighting to create a silhouette by lighting the background and keeping the subject in darkness. A simple way to do this in natural light is to place the subject in front of a window or open doorway, with the light behind it, and to take the photograph from inside. The subject will be boldly defined.

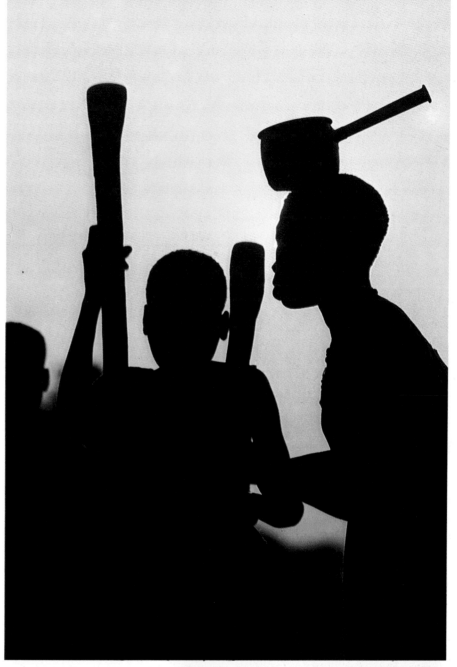

◄ The girl is carefully positioned in a doorway so that both she and the rocking chair present a clear, explicit outline. *Michael Boys*

▲ A silhouette created by shooting into the sun. *John Bulmer* positioned himself so the sun is hidden behind the figures and calculated the exposure from the sky to suppress unwanted detail.

► Silhouettes can frame a picture too: they can provide good foreground without competing with the main subject.

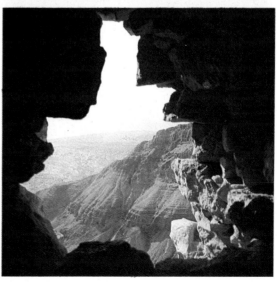

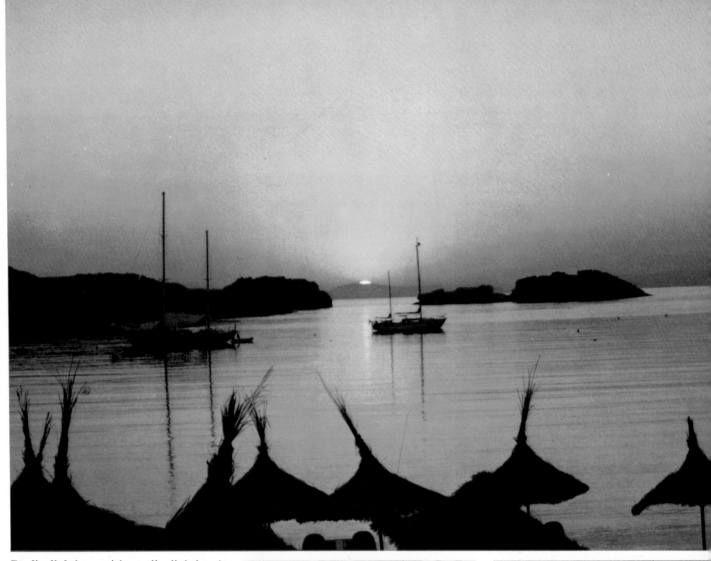

Studio lighting: with studio lighting it is, of course, possible to control the light even more finely, by directing the lamps at a white background. Any light straying on to the subject can be shielded by placing a piece of card round the light to limit it to the background only.

In all cases it is important that exposure readings should be taken from the light background areas only to ensure that the subject itself remains as an under-exposed dark tone.

The sun: shooting towards the sun is often the most convenient way of producing a silhouette, especially if the background has a light tone, like water or sand. Again, you need to expose for the highlight areas. It is also important to shield the camera lens from direct sunlight. Sun causes flare and lowers the contrast of the image, which in turn reduces the effect of the silhouette. Even an efficient lens hood is not always adequate protection when pointing the camera directly into the sun, and a useful trick is to throw a shadow over the lens by holding your hand, or a piece of card, a half metre or so in front of the lens, but of course out of its field of view.

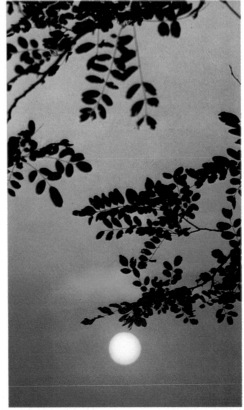

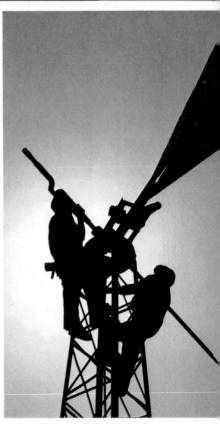

44

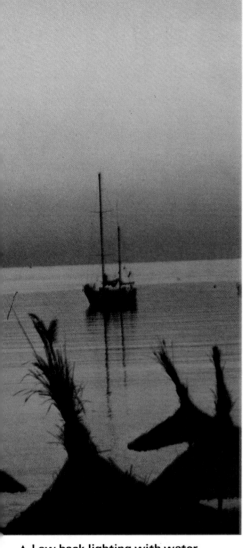

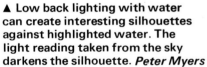

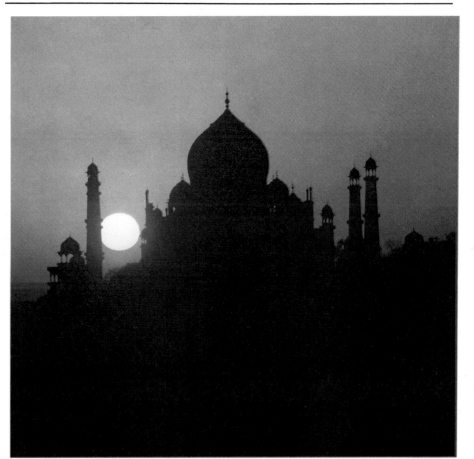

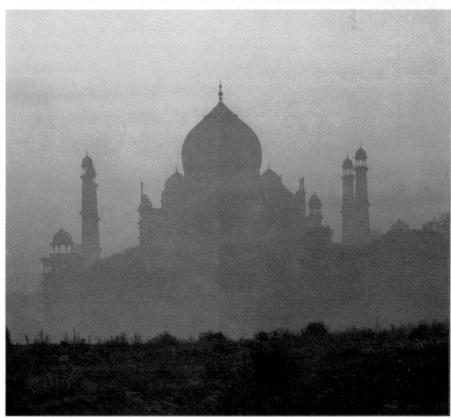

▲ Low back lighting with water can create interesting silhouettes against highlighted water. The light reading taken from the sky darkens the silhouette. *Peter Myers*

◄ Far left: good silhouette material can be found almost anywhere. A sunset framed by a pattern of leaves is more interesting than a sunset on its own. *George Rodger*

◄ Left: look out for unusual shapes. The dramatic diagonal is created by shooting from a low position and looking up. Hiding the sun behind the subject increases contrast. *Spike Powell*

► Above and below: when shooting towards the sun its position greatly influences the effect. With the sun just rising (above) the light is still quite strong, resulting in a high contrast and black silhouette. But before dawn (below) the softer light reflected from the sky creates less contrast. The top picture is exposed for sky and the lower one for the building. *George Rodger*

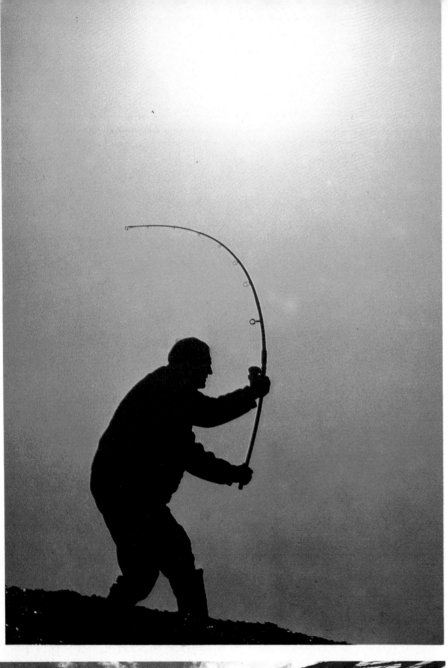

◀ A background of mist and low camera position create this bold image. The mist stops flare from the sun by veiling it. Note how silhouette conditions emphasize the tension on the rod and line.

◀ Below left: *Chris Smith* took this photograph into the sun which is masked by one of the figures. He had to crouch down low to make sure the cyclists made clean, clear shapes against the sky.

▼ Position here is all-important. *Michael Busselle* moved in slowly until the moment when the deer showed up clearly on the horizon.

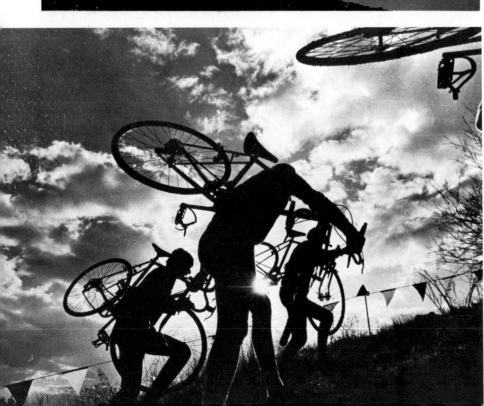

Fog and night lights: silhouetted images can be produced in fog or mist by subduing background details so that only the objects in the immediate foreground are seen clearly. A fussy and complex subject like a woodland scene can be reduced to an image of stark simplicity in mist or fog, especially when combined with back lighting. Street scenes at night can also give bold silhouetted pictures under these conditions. Exposure for subjects like these is fairly critical; too little will produce muddy tones in the background and too much will weaken the silhouette effect. A useful method is to take an average from both the darker foreground and the brightest highlight in the background.

Silhouette and viewpoint

Choice of viewpoint is always one of the most vital decisions a photographer has to make. By finding a position which gives a silhouette effect to your subject, you are in fact achieving one of the main aims of good composition —separating the centre of interest clearly from the background. There are of course other ways of doing this, such as selective focusing or colour variation. But a viewpoint which gives a bold tonal contrast between the subject and its background is the most basic and often the most effective.

You may only need to move a metre or so to right or left to bring a highlight tone in the background behind the subject, and in the case of a portrait you can move the subject as well.

A low viewpoint allows the subject to be silhouetted against the sky; you can even shoot from ground level to increase this effect. But, quite apart from the silhouetting effect, a low viewpoint invariably adds impact to a picture. Conversely, a higher than normal viewpoint often removes unwanted background tone and details— as little as 30cm can make all the difference. This is why many professional photographers prefer rigid camera cases which they can stand on to give them a slightly higher viewpoint.

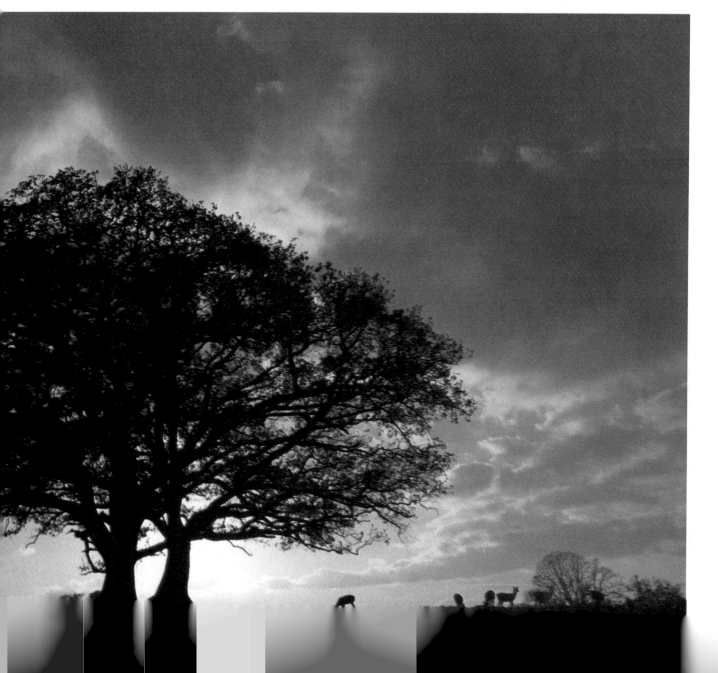

Awareness of line and shape

If you trace the main outlines of many successful photographs you will find the resulting images have a pleasing and balanced quality. This is because these lines represent the basic framework of the picture, and without a sound basis it is unlikely that a satisfying photograph will be produced.

Making tracings

With some photographs the main outlines are very clear but with others the main shapes and lines may not be immediately obvious. To discover which elements make up the basic framework

▲ A tracing of the main lines and shapes of the photograph below gives a well balanced and recognizable image. The tracing makes it

easier to see the basic composition of the picture—that is, a series of circles with a strong, carefully placed, diagonal which breaks the harmony of the circles.

▼ Bottom: the helter skelter is in partial silhouette so the picture has to rely on its strong shape for impact. Although simple, a picture like this needs careful composition: the tower must be placed within the frame in relation to the sun, so it adds interest and balances the composition.

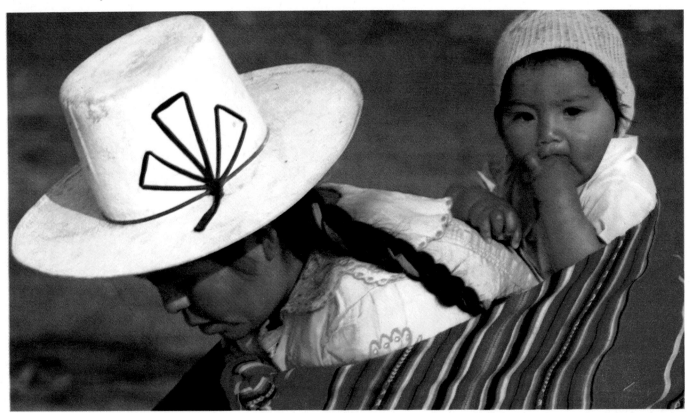

of a picture, trace the dominant lines and shapes of a couple of photographs you like and one in which you find the composition disappointing. Then compare the results; it should be quite easy to see why the one fails where the others are successful, and which elements influence the overall structure.

Dominant lines and shapes

These lines and shapes are created by a number of things:
1 The outline of the main subject.
2 When a picture includes a horizon or other equally strong division, the line it creates is usually very dominant and its position influences the overall balance strongly.

3 Boundaries between contrasting areas of tone or colour can be important elements in the composition.
4 Lines created by the effect of perspective can add to or detract from overall balance.
The effect of shape is most easily seen in photographs where the main subject is either silhouetted or boldly contrasted against the background.
Shapes created by lighting which causes strong highlights or casts shadows can be equally dominant. In hard directional light—midday sunlight, for example—contrast shapes and shadows can become more powerful than the subject. Once you start to look for them, these elements become easy to recognize. So

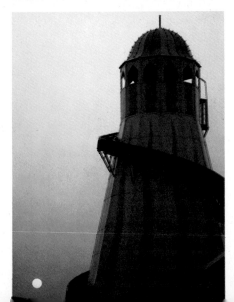

making a rough mental pencil sketch of the subject is the first important step in the process of composing your picture. Train yourself to notice these lines and shapes in your viewfinder long before you consider taking the picture. Without this awareness, creating well-composed pictures becomes a very hit-or-miss affair.

Contrast

The juxtaposition of the shapes and the way they react with each other is also important. Contrast is one way to make sure the subject gains the atten-

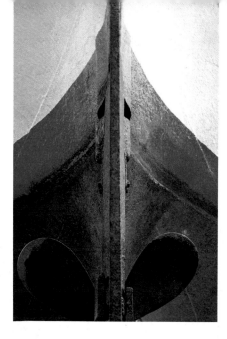

▶ It is not usually advisable to divide the interest of a picture down the middle. But in this case the dominant shapes are completely symmetrical and the strong central division enhances this effect.

▼ Horizontal lines emphasized by bands of colour produce a restful image. The photographer has taken particular care to position himself so that the trees are seen clearly in silhouette.

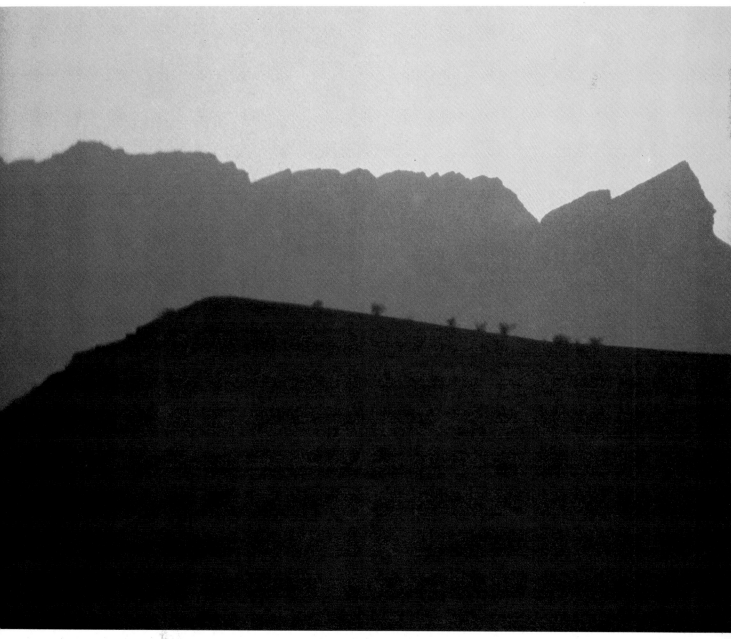

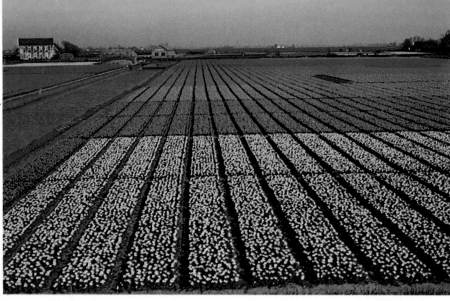

tion of the viewer, and a contrasting shape or line is an effective way of achieving this.

In a portrait, for example, the roundness of the face and eyes can be enhanced by using the model's arms and shoulders to create an angular contrast. The presence of even a small vertical line, such as a human figure or a tree on an otherwise uncluttered horizontal skyline also achieves this.

A contrast in shape alone is not always enough to achieve the desired impact; a contrast of tone or colour is usually needed as well. For instance, a red triangular sail on a blue horizon is much more striking than a blue sail would be.

Altering the mood

Quite apart from their role in composing pictures, lines and shape can have a marked effect on the mood of a picture. Where horizontal lines predominate, as in many landscapes, a relaxed and passive quality will be created. A strong diagonal line, on the other hand, is much more vigorous and assertive. Where a number of similar shapes exist within the image—the curves in a still life of a bowl of fruit, for example—the effect is usually restful and harmonious, while a variety of contrasting shapes or lines at different angles create a busy and a more exciting impression.

Controlling line and shape

With many subjects the photographer has a limited degree of control over these elements. In the case of portraits and still lives, shapes can be created at will but with landscapes it is only possible to control the choice of viewpoint and the way the picture is framed. It is often possible to minimize the effect of undesirable lines in a picture by choosing a viewpoint which allows foreground details to interrupt or obscure them. To introduce diagonal lines, photograph from a higher or lower viewpoint and tilt or angle the camera.

In a similar way, soften shapes which are too obtrusive by hiding part of their outline behind other details, or by cropping into the shape. A change of viewpoint often alters the lighting effect to reduce the tonal contrast between a shape and the background.

Once you can see which of these elements contributes to the picture and which detracts, it is usually possible to find a way of stressing the former and subduing the latter. And if no solution is possible, your awareness of the fact will spare you from a disappointing result and wasting your film.

▲ *George Rodger* climbed on top of a shed (about 6m high) to gain an elevated viewpoint—essential to capture the interplay of perspective on the repeated straight lines of this tulip field. Taken with a Leica 50mm lens with UV filter, on a bright but overcast day.

▼ The rhythm of curves and lines in the Sydney Opera House adds up to an exhilarating, almost abstract composition. When photographing buildings, look for repeated lines and see how they echo or conflict with the shape of the subject. *Gordon Ferguson*

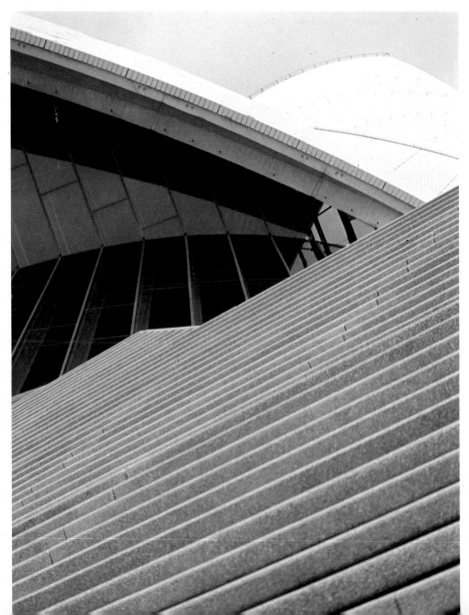

▲ Look for repeated curves or lines in haphazard arrangements.

▶ Contrast of colour and shape prompted Michael Busselle to take this picture. Try altering your camera position to make sure the contrast is most effective.

▼ Try looking at shapes from above (over a cliff, for example). The strong diagonal of this pier is emphasized by bright directional sunlight while under-exposure deepens the shadow.

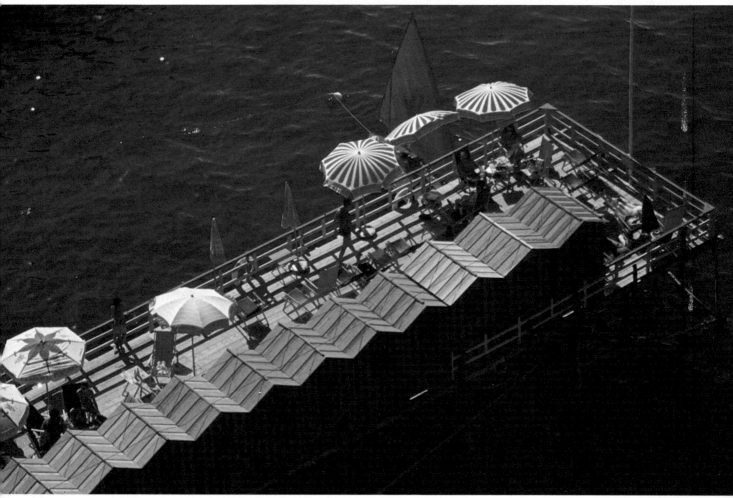

Discovering pattern

We live surrounded by pattern. In photography these patterns can tease, amuse or stimulate the visual imagination. Skilfully used, this repetition of shapes or lines within a photograph help create a rhythm and order that can make a particular picture memorable. The patterns the photographer uses need not always be exact geometric repetitions like the arches in a colonnade; they could be an impression of a pattern, such as the expanding ripples of water, or tracery of branches against the sky.

Where to find pattern

Finding patterns is very much a question of being aware. To develop your 'eye', look out for pictures with a strong element of pattern and see how they are formed.

Pattern can exist almost everywhere. There are two main types—transient patterns which exist only at a certain moment or from a particular viewpoint, such as the faces of a crowd at a football match, in a flock of flying birds or a parade of soldiers; and static patterns which are man-made or created by nature, such as the windows in an office block or a row of houses, the bark of a tree or the ripples left in sand after the tide has gone out.

How to use pattern

It is unlikely that a picture relying solely on pattern will have any lasting appeal—although it may have an initial impact—so pattern should be used only as a strong element of a picture and not as the sole reason for taking it.

A strong pattern can create a reassuring, restful and ordered atmosphere in a picture. But remember that patterns are usually quite busy and complex, so the main subject of the picture should be simple and bold, and placed in a strong position within the frame, otherwise it may be completely overwhelmed.

▶ **REPETITION**
A far more dynamic effect is created by this diagonal pattern of soldiers than by the usual straight-on rows. The build-up of repeated shapes, repeated angles, repeated details, all contribute to the overall result. The high position is important; at ground level the pattern would not have emerged as clearly. Notice too how the epaulettes separate the rows dramatically.
Bruno Barbey

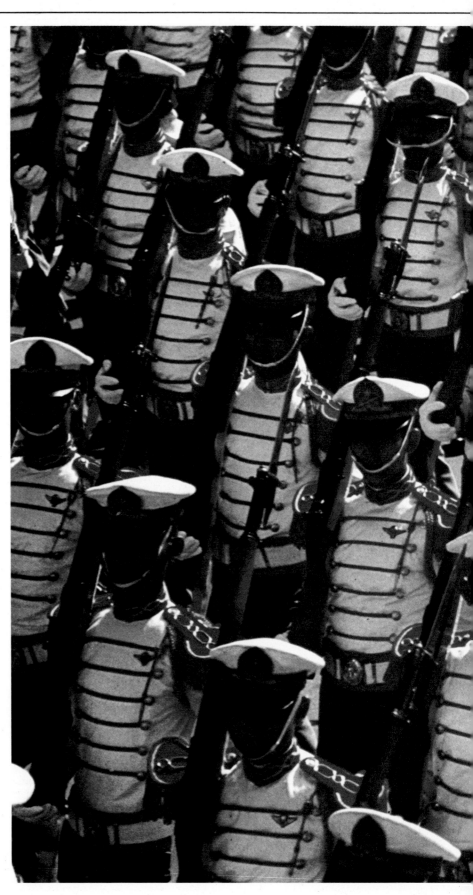

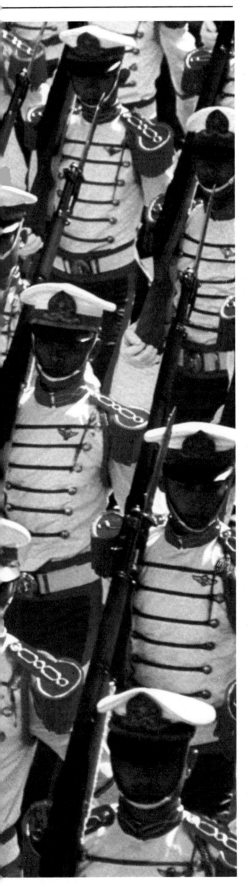

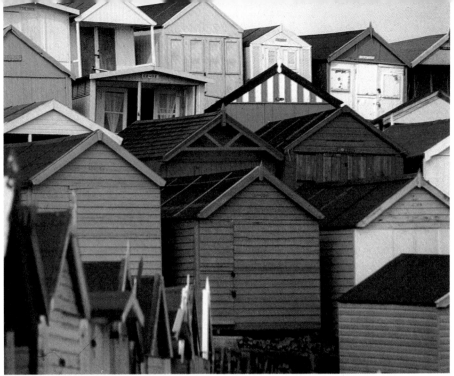

▲ This apparently higgledy-piggledy mass of beach huts is held together by the strong underlying repetition of the triangular roofs. *Michael Busselle* juggled about with the viewpoint until he found the most effective combination of colours, perspective and play of light and shade. Now approach the idea another way: if the huts had all been in straight lines—each shape, colour and angle identical— the picture would lose the interest created by oddities in the pattern.

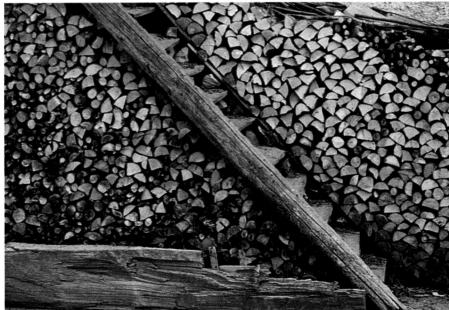

Sometimes purely repetitious pattern can be boring—especially when the scale suppresses individual quirks and surprises—as in the picture of a pile of logs (right). But as a background to the strongly diagonal ladder the logs work well, throwing the ladder forward and not competing with its lines in the way a more varied background, such as a collection of farm implements, might have done.

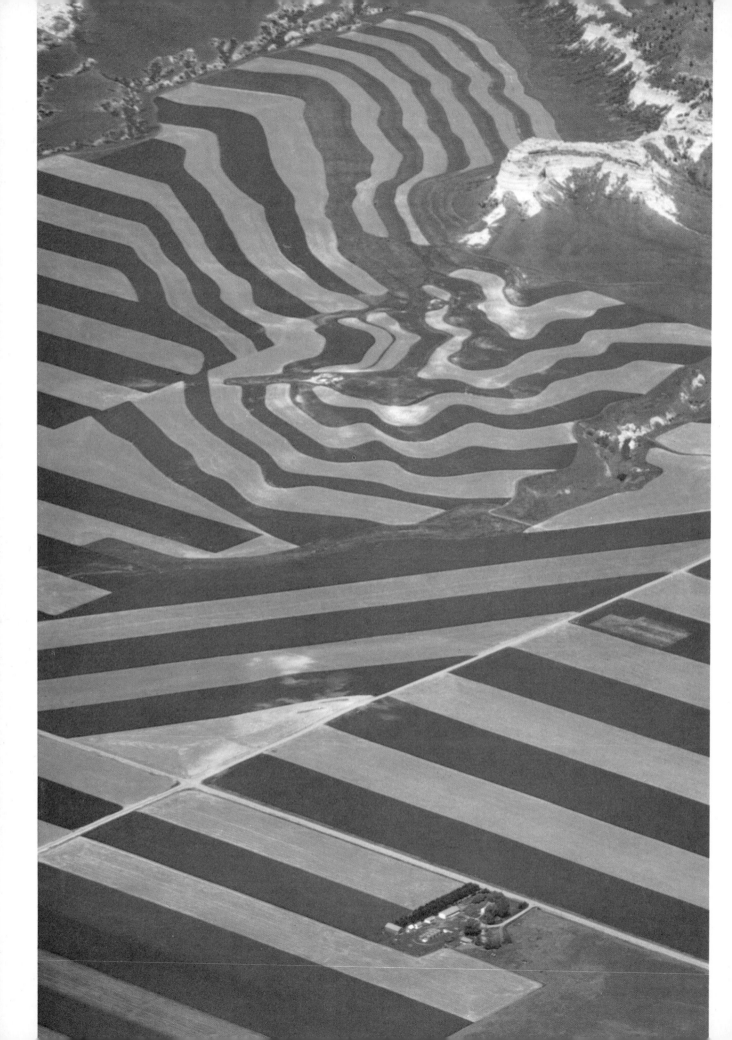

◄ Once you notice the farm building at the bottom, the whole picture acquires a sense of scale. You see the scene again in this context and suddenly it's not an abstract design, but a pattern created by the contour of the land and the ploughing of the field—a marriage of both man's and nature's influence.

How light affects pattern

A subject which has an inherent pattern, such as a pile of logs or a row of houses, may not be greatly affected by a change of lighting, but there are other images where the pattern is created or revealed by the nature of the light. A pattern of this sort may only exist for a short time. Take, for example, the patterns caused by sunlight on the ripples of water. It is quite easy to photograph a couple of dozen frames on a subject like this and

for each one to be quite different. In many instances it is the shadows which make a pattern, and a slight shift in the angle of light causes the pattern to disappear.

Pattern and colour

Pattern is made up of lines and shapes. In a black and white photograph these are formed by highlights and shadows and contrasting shades of grey. In colour photography, lines and shapes are often formed entirely of colour and

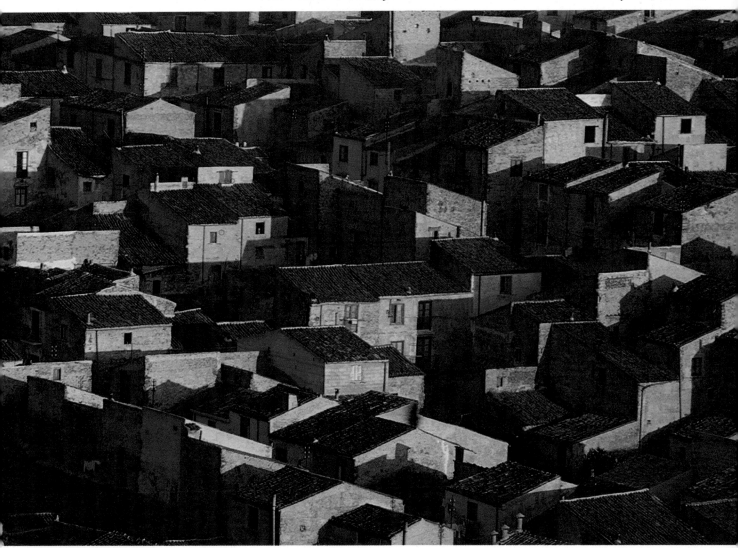

◄ This reflection of a colourful boat on rippling water makes a transient pattern which will change with the movement of water and the position of the sun.

▲ An Italian village, seen at late afternoon when the sun is at an angle. Very strong lighting has created dense shadows and strong highlights, making a pattern which would be equally obvious in black and white.

the colours of the subjects become as important as highlights and shadows. In many instances strong colours make a pattern obvious and it is quite possible for a pattern to be produced by colour alone. The colours in landscapes and woodland scenes often make strong patterns. Close-up photography often reveals beautiful patterns in the colours of flowers and insects, or in the rainbow patterns found in soap bubbles and oily water.

Patterns exist everywhere but the photographer must be prepared to look for them. It is really only a question of 'tuning in' visual awareness to uncover a limitless source of subject matter.

Pattern can be man-made or it can occur naturally. It can be revealed by lighting or colour or by a changed viewpoint. All these pictures contain strong patterns of one sort or another. Some are immediately obvious, such as the repeated shapes of the honeycomb, the sea urchins, the cars seen from above, or the house fronts. Others, such as the umbrellas or the stone wall, depend on the lighting to make the pattern obvious. Often going in close on a detail will show pattern more effectively than photographing the whole—for example, the pattern of leaves (top left) or the fir trees.

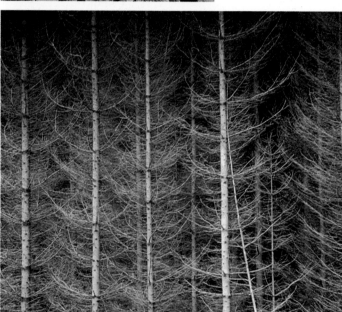

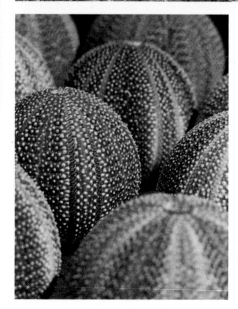

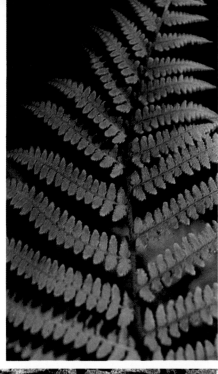
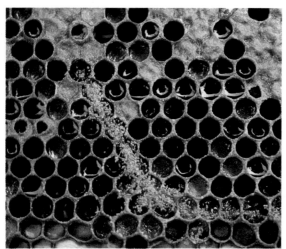
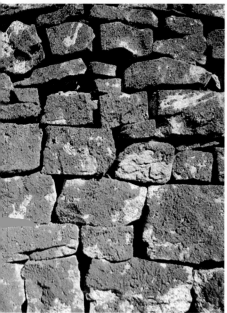
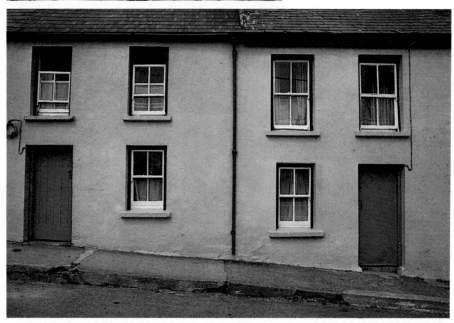

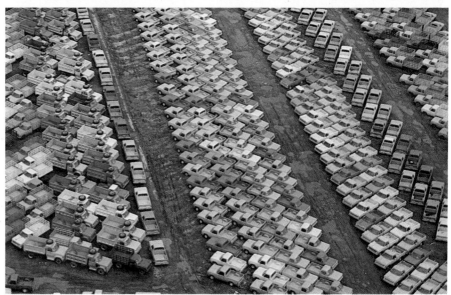

Emphasizing texture

One of photography's special qualities is its ability to convey texture so realistically that you can tell what objects would feel like just by looking at pictures of them.

The texture of a surface shows how it feels to the touch—whether it is rough or smooth, hard or soft. It is possible to take a picture of a group of objects——a piece of metal, an egg, some silk and an orange, for example—and give a really accurate impression of how each one would feel. Indeed, wood grains can be printed on laminates so convincingly that you have to touch them to tell genuine from fake.

Texture for realism

The ability to convey texture is vital for pictures that are intended to look particularly realistic. Some of the best examples are seen in food and still-life photography, where the photograph sometimes becomes almost more real than the product. And if you want an unreal quality, texture is the first thing to go—dream sequences in films are almost always shot with soft focus attachments, whereas to show texture the image must be as sharp as you can get it.

Professional still-life photographers often use large format cameras when photographing for texture but it is quite possible to get very effective results with smaller cameras. They must be accurately focused, and kept very still, and the aperture must be small enough for adequate depth of field. A fine grained film is usually best for emphasizing texture.

How light affects texture

The way you light an object to reveal texture most effectively depends largely

▼ **A full range of textures, from fabric to metal, is reproduced here.** *Michael Newton's* **use of soft, low-angled lighting highlights the individual textures.**

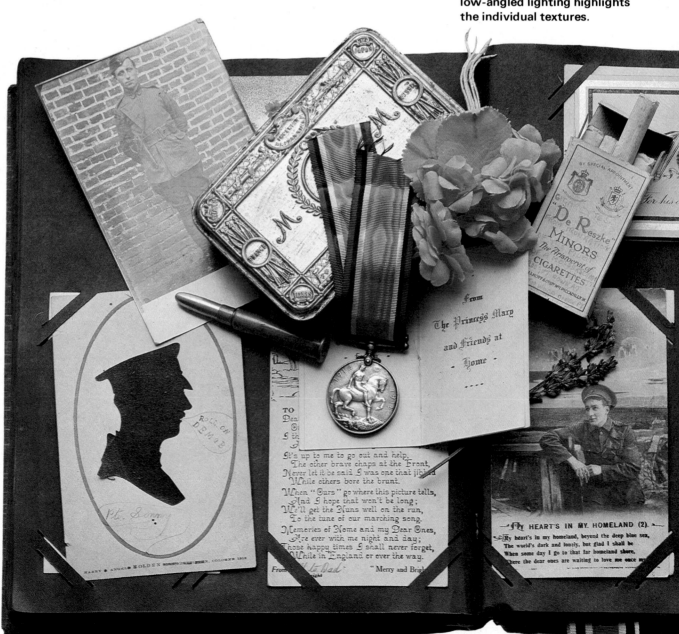

▶ *Paul Forrester's* skilful use of lighting picks out the texture in this food shot. Here the combination of lighting, fine grain film, small aperture and camera angle all contribute to the strength of the texture. Although shot on large format, high quality is possible with a slow 35mm colour film, such as Kodachrome.

▼ Right: close camera position and precise focusing isolates the detail of texture. *Eric Crichton*

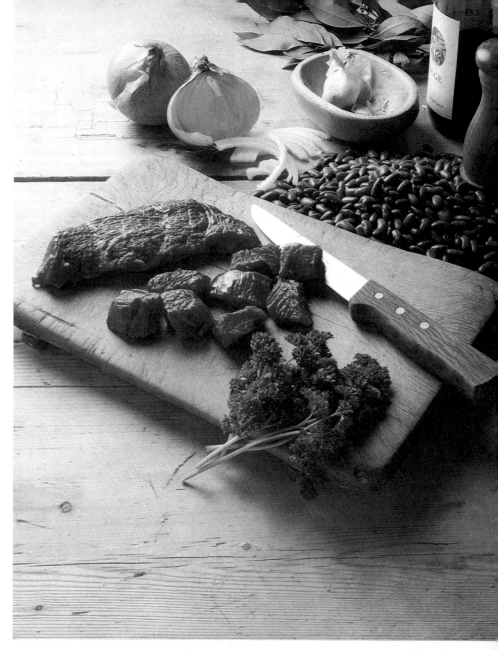

on the surface you are photographing. A subject with a coarse texture and wide range of tones, like the bark of a tree, can be quite effectively photographed with just a soft (large source) frontal light. However, a surface with a subtle texture, such as an orange, which also has an even tone and colour, would need to be lit in such a way that highlights and shadows are created within the tiny indentations of its skin. This usually means that the lighting should be quite hard (fairly small source) and directed at the subject from an acute angle so that it literally skims across the surface.

With a subject which has a more pronounced texture, such as a stone wall, slightly softer lighting at an acute angle is preferable, otherwise the shadows created by the indentations become too large and dense.

Shape is also important: with a flat surface such as a stone wall lighting has the same effect over the whole surface whereas the lighting on a rounded surface, such as an orange, varies.

As a general rule, the more subtle textures require lighting which is harder and more directional than surfaces with a more pronounced texture. But to achieve the best results you have to be aware of the distribution of highlights and shadow tones, and the gradations between them, which the lighting creates on the surfaces of your subject. If you are going for textural quality above all else, you may find that the techniques used create undesirable effects in other elements of the picture. For instance, in fashion photography the lighting used to bring out the texture of cloth won't do much for the model's skin.

How to accent texture

One method of accentuating texture is to increase the contrast of the lighting, either by directing it from a sharper angle when it is controllable, like studio lighting, or by changing the camera position.

Photographing towards the sun is an effective way of doing this, especially when it is low in the sky. Don't point the camera directly at the sun but position it so that its angle to the surface being photographed is roughly equal to the angle at which the sun

▶ **The low sun will pick up the sand's texture but produce strong shadows, so it is wise to bracket exposures. Here the photographer has no control over the lighting.** *George Rodger*

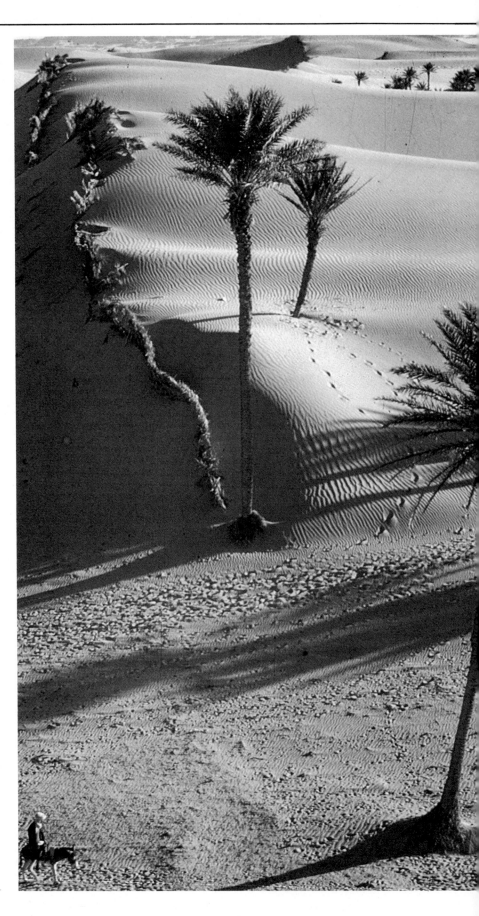

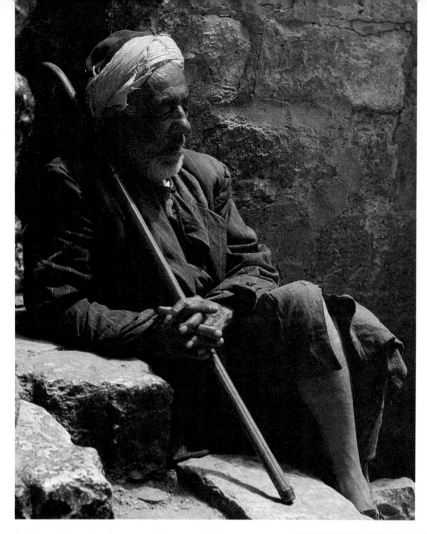

▲ Bark has a very pronounced texture which would be obvious in almost any lighting. Hard, directional light, here good for the texture, often creates dense shadow and loss of detail.

◄ Similarly, skin texture can be revealed by hard, directional lighting. This type of lighting is usually more effective on dark skins than on white, where it tends to be unflattering. *Michael Busselle*

► By taking the camera close in, *Eric Crichton* has emphasized the inherent texture of this cabbage. Here soft lighting is essential to record the delicate texture at the edges of the leaves, which would become lost in the shadows from a strong directional light.

▼ The problem is similar in *Colin Barker's* close-up of a leaf, where the texture is only made obvious by the extreme close-up.

► Below: texture like this peeling paint needs strong side lighting where there is no colour contrast to make it really obvious.

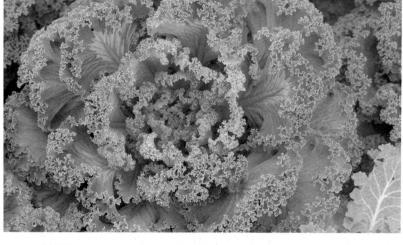

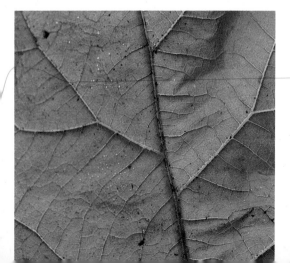

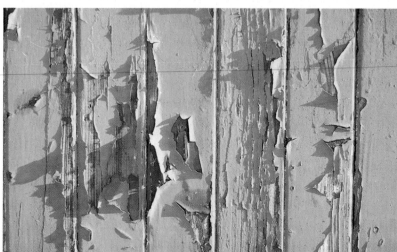

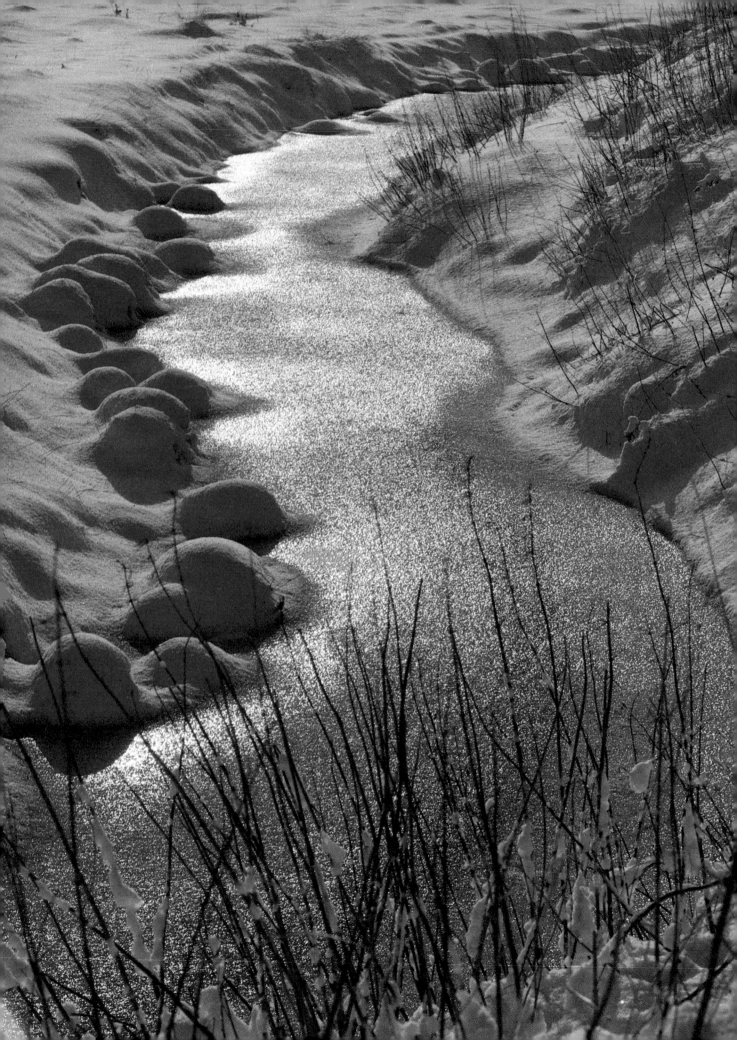

strikes it, so increasing contrast.

Contrast can also be increased by your choice of film: the slower the film the higher the contrast. In black and white photography (and with certain colour films) it is possible to increase the contrast by using special processing techniques. But although it is possible to create exaggerated effects in this way, it is at the cost of subtlety, and other elements of the picture may have to be sacrificed.

Exposure can quite often be used to accentuate texture, particularly if you use lighting with a reasonably high contrast range. In this situation a degree of under-exposure will often effectively increase the textural quality of the subject. Skin tones in a portrait, for example, will have a stronger texture when they appear darker than usual—the portraits of Karsh often display this technique.

The opposite technique is of course used to minimize skin texture, as in fashion and beauty photography, where a soft, frontal light creating a low contrast range is often combined with a degree of over-exposure to create a more ethereal effect.

But the key to a picture showing strong texture is a really sharp image. Although lighting, camera angle and exposure can all contribute, success ultimately depends on a really crisp picture with good definition. Make sure the camera is accurately focused and try and stop down to at least f8. If this means a slow shutter speed be sure to use a tripod.

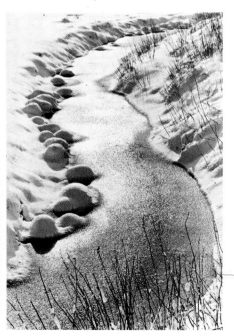

▲ Slight under-exposure will often bring out skin texture in portraits, as in this *Karsh* picture. Use this technique with care as it can bring out unflattering blemishes as well as character.

◄ A picture which works as well in black and white as in colour (far left). Low back lighting creates strong highlights, shadow and sparkle. The strong highlights could cause under-exposure, so take a reading from a middle grey area or bracket exposures.

▶ Take away texture and you take away realism. Soft focus gives a dreamy, romantic image.

Tone and contrast

Tone is the difference in density between the lighter and darker parts of a photograph, ranging from white at the one extreme, to black at the other. In between lies an infinite variety of tones and it is tonal contrast (or the relationship between these tones) which gives three-dimensional form and depth to a picture. The tonal contrast of an image is affected by the lighting of a subject, its colour and its reflective qualities.

In colour, the same principle applies, although technically the darker tones—in the green of a leaf, for example—are called shades, whereas the lighter tones in a picture are called tints.

Tone and form

If a two-dimensional photograph is to imply a third dimension it needs to include the full tonal range with subtle variations. Much of the photographer's skill lies in recognizing these tones and recording them accurately. First, you need to become aware of them in your subject, even in something which is white. A cloud, for example, is very rarely white all over; it is usually a gradation of white and grey and it is these gradations which give the cloud form and depth.

▶ To achieve a full tonal range you need to balance the tonal quality of the subject with lighting, precise exposure and correct contrast in processing and printing.

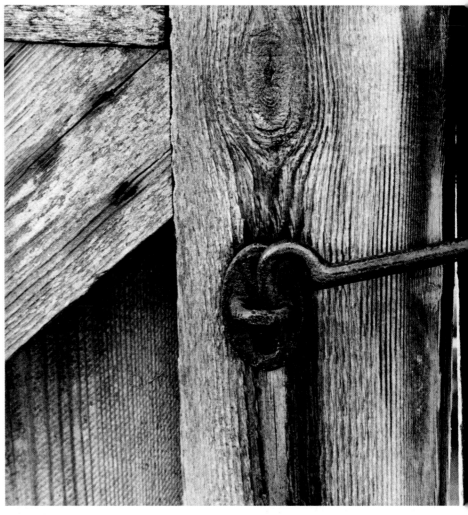

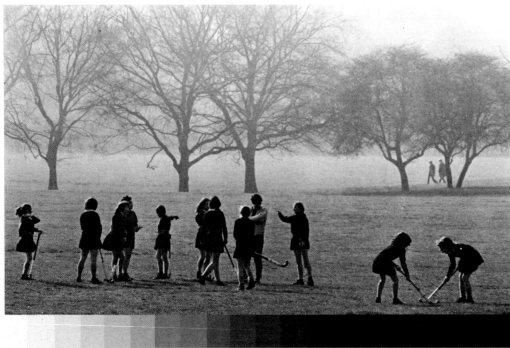

◀ Most of the tones in this picture are only a slight variation on mid-grey, as the grey scale below shows. This results from soft lighting accentuated by processing and printing. Higher tonal contrast in the picture could have made the overall effect too fussy. *Herbie Yamaguchi*

▶ Difference in tone between background and foreground add to the feeling of distance created here. The limited—but high —contrasting tonal range is the result of lighting conditions—mist and early morning backlighting— which produces the very pale background with the foreground almost in silhouette.
Herbie Yamaguchi

How light affects tone

If you photograph a white billiard ball (or an egg) and a disc of white card the same size, and light them from the front so that no shadows or highlights are created, there will be no visible difference between them. If you then move the lighting to the side to create shadows, the difference will immediately be obvious. The white ball will develop a full range of tones from white on the lit side through shades of grey to black in the deepest shadow, and so becomes three-dimensional.

Light which creates shadows is also creating tone. You can see the relationship between light and the tones and shadows it creates virtually anywhere—from the window light on a fellow passenger's face in a bus or train to the sunlight on the landscape through which you are travelling. A hard (small source) light such as direct sun creates solid tones with clearly defined steps, whereas the soft light of a cloudy day produces gently changing tones and shadows with imperceptible edges.

How tone affects mood

There is a strong connection between the tonal range of a photograph and the mood it conveys. A picture which consists primarily of the darker tones in the range gives a sombre and serious atmosphere whereas a picture with a full range of tones, bright highlights and crisp shadows creates a lively and cheerful impression. A photograph

The two white bottle pictures show how lighting affects tone and how a large tonal range brings out form and distance. The same soft lighting is used for both but front lighting (below) has produced an almost shadowless image, which makes the picture look flat. Half-side lighting (above) gives strong, well-placed shadows, adding form and depth. *Michael Busselle*

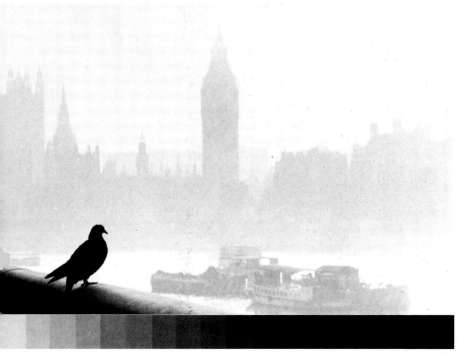

▲ Low key pictures are usually found, not created. The sombre, serious mood is helped by slight under-exposure. *Michael Busselle*

▼ A high key picture has light tones with little contrast, but there are usually areas of fine, bold detail in a darker tone, almost like a pencil sketch. *Robin Laurance*

made up of lighter tones has a delicate and often romantic quality.

So the tonal quality of your picture should illustrate the mood you want to convey—a dark-toned (low key) picture of children playing on the beach would be as inappropriate as a delicate light-toned (or high key) portrait to show the character of Count Dracula.

Tone and contrast

Contrast is the relationship between the darkest and lightest tones in a picture. A photograph which has a full range of tones with detail in all but the brightest highlight is considered to be of normal contrast. A picture dominated by very light and very dark tones, with little tonal variation between, is described as high contrast. Where there is only a small difference between the brightest and darkest tones you get low contrast image.

Contrast is partly controlled by lighting. A hard directional light such as bright sunlight tends to create a high contrast image while very soft light—a heavily overcast day, for example—creates a low contrast image.

Colour and contrast

Light and dark colours in a subject give it contrast which is independent of that created by lighting. For example, a bride in a pale wedding dress standing against a dark church door is a high contrast subject, whereas the same bride standing against a white wall would be a low contrast subject. You can also control the contrast in your photographs by the way you handle the lighting. Harsh sunlight will emphasize contrast, producing hard shadows and giving extremes of tone. If you want to reduce this contrast, wait until the harsh direct sunlight has become diffused by clouds.

Developing and printing

In black and white photography, and to a lesser extent with some colour films, it is possible to control contrast by varying the development times; the longer the time, the greater the contrast. Conversely, less development means less contrast. The choice of printing papers can also affect the contrast. Taking grade 2 paper as normal, using grades 3 to 5 will give a higher contrast picture and grades 1 to 0 will give a softer result.

To sum up

For a wide range of tones
- Wait for—or create—softer diffused lighting.
- Calculate your exposure carefully: if in doubt, bracket exposures.
- Develop and print according to manufacturers' instructions.

To increase contrast
- Use harsher, direct lighting.
- Under-expose by about 1 stop.
- Increase development and/or use a more contrasty printing paper.

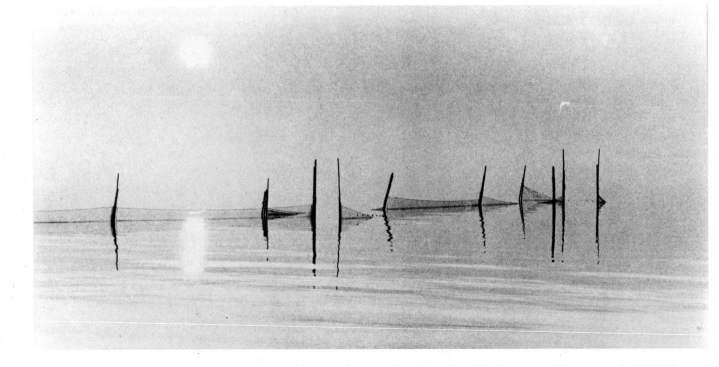

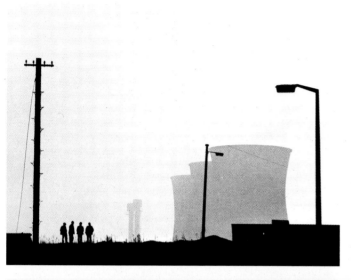

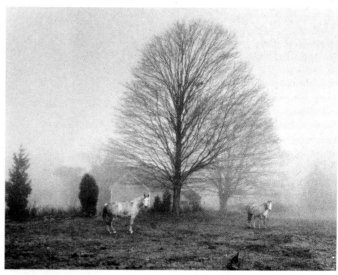

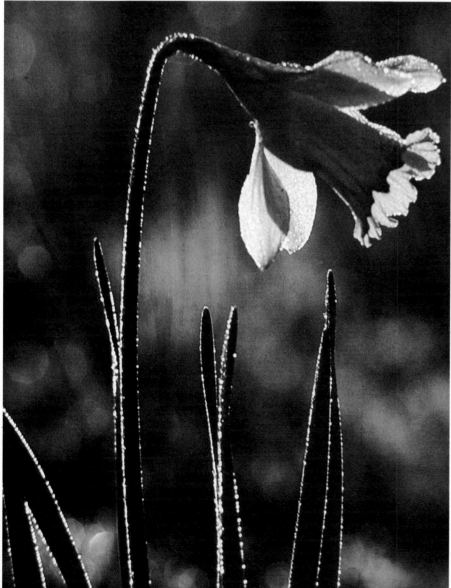

Top left: back lighting with a slight haze and high contrast paper gives a high contrast image. The exposure needs to be just long enough to keep the light areas clean without unwanted detail in the foreground. *Bob Kauders*

Left: the high contrast is totally a result of exposing for the very strong back lighting. *Richard Tucker*

Top right: this low contrast image is the result of very, very soft lighting and slight mist. A soft grade of paper should be used for this effect. *Jonathan Bayer*

Below: low contrast in colour. The tonal range here is lower than may at first appear because there is quite a large colour difference. *Michael Busselle*

Seeing in black and white

Many photographers still prefer to use black and white because, although you cannot rival colour for realism, black and white is often more immediately expressive. Working in colour may be a distraction in certain circumstances, too—for example, in some documentary photography, or when the natural colours of the subject are not very pleasing. Without colour the image is simplified, allowing the shape, tones and texture to be emphasized.

Colour as black and white

To produce good black and white photographs the world of colour around us has to be seen as shades of grey. The change of approach is so marked that many experienced photographers find it difficult to shoot both black and white and colour pictures at the same time.

One of the main problems is that colours of the same intensity, which may look very different in colour, appear as the same tone of grey on black and white film. Take, for example, a scene of a boat with a bright red sail against a blue sea. This would look quite striking and have considerable contrast in colour but in black and white it would appear as

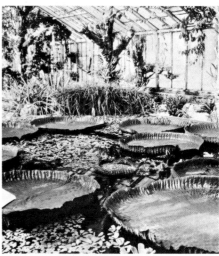

grey on grey and rather flat. When you start looking at the world in shades of grey you will see that what makes a good colour picture is very rarely as good in black and white.

If you have difficulty visualizing a scene in black and white, there are filters—Kodak Wratten No 90 and Monovue—which will help you judge its tonal values. These are dark, greyish-amber filters, made specially for monochromatic viewing. The Kodak also comes in a cheaper gelatin version. This can be placed in a transparency mount for protection and easier handling.

Light and black and white

Light changes tonal values and is of course vital to all photographic pro-

Right and below: you have to look carefully at the tonal values. These radishes show what happens to colours of the same intensity. The red and green give a strong contrasting image but in black and white the contrast in tone disappears.
Michael Newton

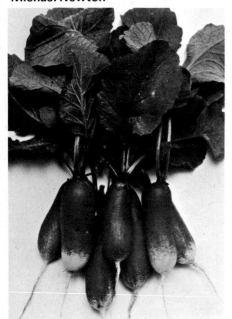

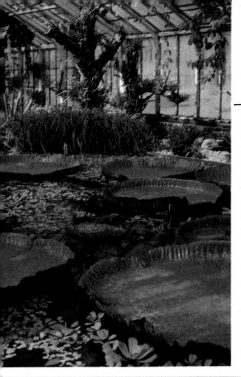

Left and far left: this garden is a complicated scene which depends on colour to separate the various elements. These colours look well together but there is not much tonal contrast. In black and white the tonal values emerge as a rather fussy, distracting arrangement of details. *Gunter Heil*

Right and below: this is a picture which works better in black and white; in colour it is rather flat. By increasing the contrast in the black and white print—using high contrast paper and giving the sky extra exposure—we have an image rich in contrast. *Michael Busselle*

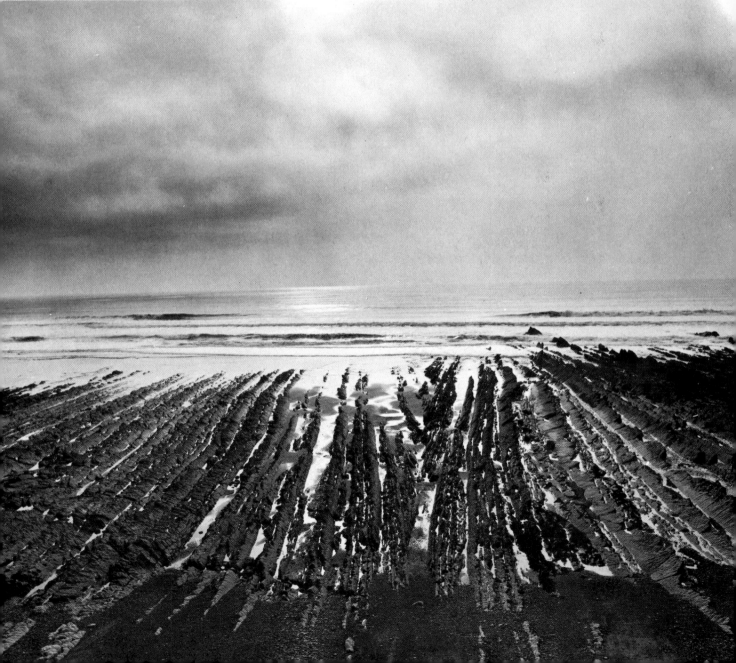

cesses, but it has a special importance in black and white photography. The example of the red-sailed boat on the blue sea, which looks flat and grey in black and white, could easily be converted into an exciting black and white image by a change of lighting. For example, if the picture was taken into the sun so that the grey sea became highlighted and recorded as a much lighter tone, the grey sail would in turn become silhouetted and record as a much darker tone. The resulting picture would then have impact and contrast.

So the tonal range of a scene becomes important, and to a large extent it is the lighting which creates the tonal quality of a picture. Taking photographs in black and white is an excellent way of learning how to understand and use light.

Filters

Modern panchromatic black and white films have quite a well-balanced sensitivity to each colour, which is why colours of the same brightness record as a similar tone of grey. But you can change the film's response to colour by using coloured filters which are designed to add contrast in black and white photographs.

These filters come in the form of discs or squares of coloured glass or plastic which are mounted in front of the camera lens. They work on the principle that they will pass light of the same colour as themselves but will hold back light of other colours. This effect depends on the strength of the filter. For example, a full-strength primary blue filter will pass blue light only and will prevent all red and green light from affecting the film. A pale blue filter, on the other hand, will only hold back some red and green, thus slightly reducing the contrast.

Colour filters give you considerable control over a black and white film's response to colour. Going back to the example of the red sail and the blue sea, you could use a strong blue filter to record the sea as a much lighter tone and the red sail as nearly black. With a strong red filter the sail would record as nearly white and the sea as very dark grey.

Few of the colours around us are pure hues, so the red sail may well reflect some blue and the sea some green. Even with a full strength filter the effect is therefore rarely total.

Once you have become aware of how to 'translate' the colour you see into black and white images, you can begin to create more powerful, dramatic pictures. You will be able to see when black and white would be more effective than colour. For example, the low-light situations where flash is out of the question, such as concerts, boxing matches, or social functions; here, colour would add very little and a fast black and white film is best.

COLOUR TO BLACK AND WHITE
The two sets of boxes give an idea of how colours come out in black and white. Look at the tones which appear the same in the bottom row and then compare them with the coloured versions.

▶ News photographs such as this one seldom gain impact in colour because their effect depends more on the emotional content from which colour would detract.
Don McCullin

▼ As a colour picture the yachting scene has quite a strong composition largely due to the bold contrast between the orange sail and blue sea. In black and white (right) the sail becomes a medium grey and there is no longer a strong contrast. With a blue filter (below right) the sail becomes darker, the sea lighter. *Michael Busselle*

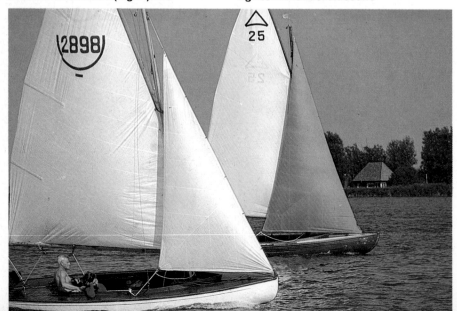

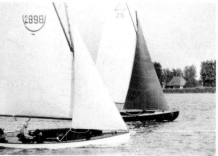

Giving pictures scale and depth

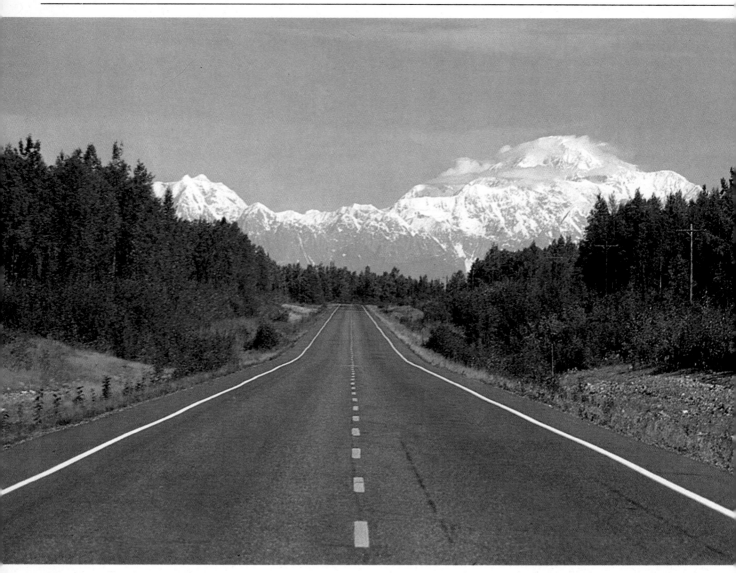

One of the greatest limitations of photography is that it has to show a three-dimensional subject by using a two-dimensional medium—a piece of photographic paper or film. However, when you look at a photograph you don't usually experience too much difficulty in assessing the depth and form of the objects contained within the picture. This is because there are clues to help you, and one of the most important of these is perspective, and more particularly linear perspective.

It is linear perspective that governs the shape and size of objects in relation to their distance from the point at which they are seen—the viewpoint.

Another aspect of perspective is that which governs the tonal quality of an object in relation to viewpoint. This is known as aerial or atmospheric perspective. However, for the purpose of this chapter, perspective is used to mean

linear perspective.

As a photographer, the more you learn about the tricks of perspective and how to use them the more you can create a sense of dramatic 3-D depth to suit the subject of your pictures.

Converging lines

Everyone knows that if you look down a railway track the rails appear to converge. They get closer and closer together until, at a considerable distance away, they appear to touch. The sleepers also appear to get smaller and closer together. Yet, if you were able to walk along the track with a measure, you would find that the rails were the same distance apart and that the space between the sleepers remained constant, however far down the line you walked. This apparent convergence is due to an effect called perspective—the fact that objects nearest to us always

▲ The use of converging lines, which the eye accepts as indicating distance, is one of the most simple and effective ways of giving a picture a feeling of depth. By standing in the middle of the road to take this picture *Steve Herr* has further dramatized the effect.

appear larger than identical objects placed further away.

A railway track is a simple and obvious example because we know that the lines are the same distance apart, but the effects of perspective are with us all the time. The buildings seen when looking down a street, even if they are not all identical, appear proportionally narrower and proportionally less deep (smaller) the further they are from the viewer. The brain, however, because it uses previous knowledge and experience, modifies the eyes' accurate image and tells us that the buildings are

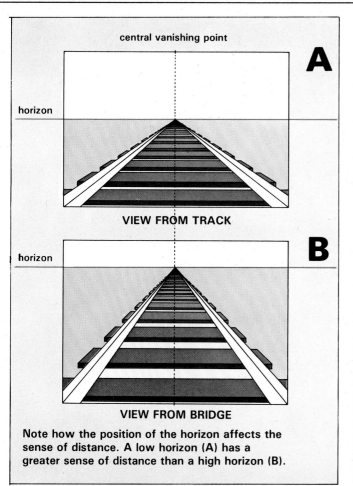

central vanishing point

A

horizon

VIEW FROM TRACK

B

horizon

VIEW FROM BRIDGE

Note how the position of the horizon affects the sense of distance. A low horizon (A) has a greater sense of distance than a high horizon (B).

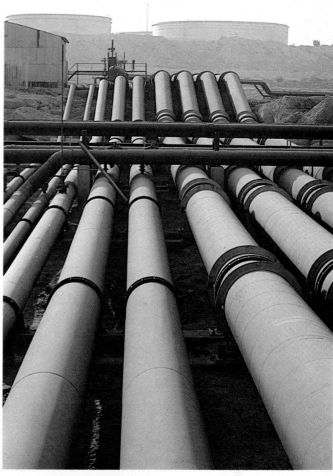

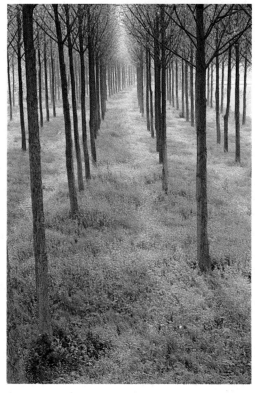

Including parallel lines which appear to meet in the distance is not in itself enough to make a good picture with plenty of depth. You have to choose a viewpoint from which this aspect of perspective can be best exploited to reflect the mood you wish to convey. *Paolo Koch* chose a low, central viewpoint for the picture of oil pipes in Iran (above), exactly right for a feeling of power and industry.
Lisa Mackson used a high viewpoint to draw the eye down into the quiet seclusion of the woodland scene (left).
John Bulmer stood slightly to one side to lead the eye from the front of the picture to the train (far left), while making the most of the curve at the end of the track.

the same size along the entire length of the street. You may *know* this to be true, but it is not the image received by your eye. Your brain has translated the information and decided to ignore perspective.

So, having established that your brain has been tricking you all your life, as a photographer you must now start trying to see what your eyes actually register. Because the camera does not have a brain, it will not ignore perspective. So learn to rely more upon your eyes and less on previous experience.

Vanishing points

Vanishing points and the horizon are two essential elements of perspective. Taking the railway track as an example again, you can see that the lines appear to converge at a point which is as far as the eye can see, and then disappear. This is the *vanishing point*.

In any one scene there may be more than one vanishing point. If you stand between the rails and look along the track you will see that there is only one, central, vanishing point (see diagram A). However, if you turn your head and look at a building from a corner (diagrams C, D, E and F) there are two, one on either side. Whatever their number, however, and whichever direction you look in, from the same viewpoint all vanishing points are on the same horizontal line, beyond which you cannot see. This line is the *horizon*.

Viewpoint

The position of the horizon, and of all the vanishing points along it, depends entirely on your viewpoint. By changing your viewpoint you change the position of the horizon, and so alter the perspective.

The 'normal' position of the horizon is at eye level (see diagram A) but, by moving higher up—on to a bridge, for example (diagram B)—you extend your area of vision and the horizon changes. The higher your viewpoint, the higher the horizon.

If you lower your viewpoint, objects appear to grow. A building appears larger because it towers above your normal eye level, indicating that it is very tall in relation to your viewpoint. Conversely, if you get much higher the building appears to become a scaled-down model of itself.

So changing your viewpoint affects the position of the horizon and alters perspective, which, in its turn, governs the

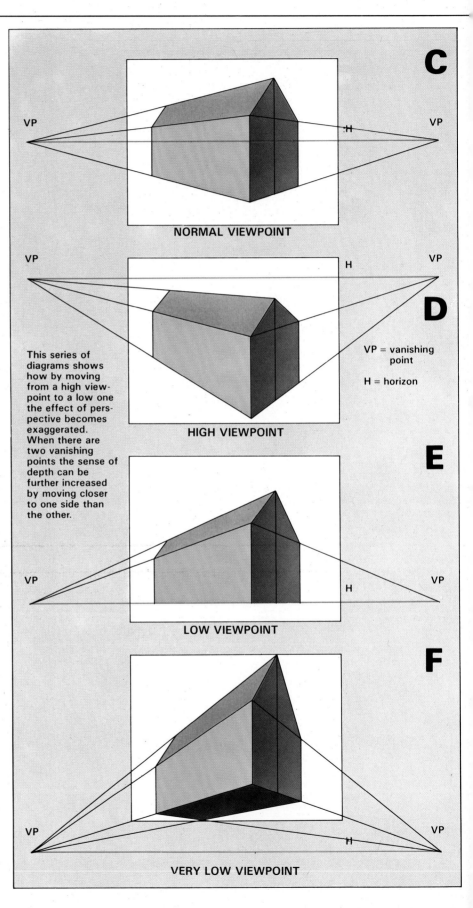

C NORMAL VIEWPOINT

D HIGH VIEWPOINT

This series of diagrams shows how by moving from a high viewpoint to a low one the effect of perspective becomes exaggerated. When there are two vanishing points the sense of depth can be further increased by moving closer to one side than the other.

VP = vanishing point

H = horizon

E LOW VIEWPOINT

F VERY LOW VIEWPOINT

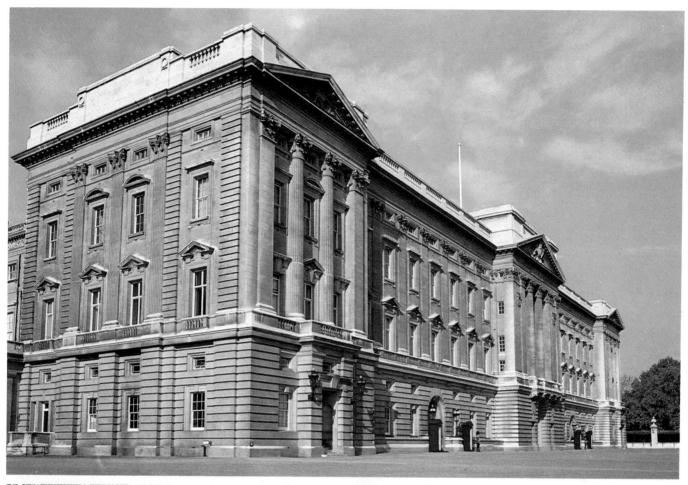

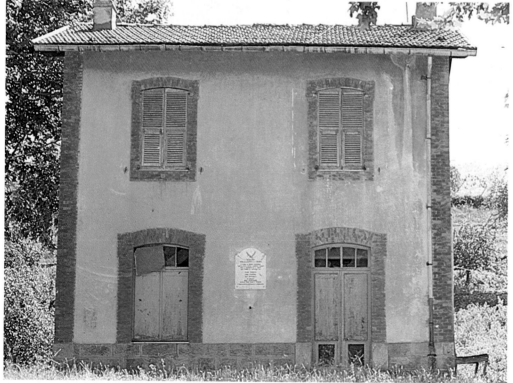

Two vanishing points are better than one! Especially when it comes to emphasizing the three-dimensional quality of a subject. Take a building, for example—it has two surfaces which meet at right angles to each other so there are two vanishing points, one from each surface. You may not be able to get both, or even one, of these in the shot. But, by positioning yourself in the front of the point where the walls meet, so that both are seen at an angle (above), you can suggest the vanishing points outside the edges of the picture. This will give a greater sense of depth than a shot from head on to just one surface (left).

visual impression of scale. It follows, therefore, that with a very high viewpoint, such as from a helicopter, you could photograph a building as tall as the United Nations Center in New York so that it would assume the scale of a king-size cigarette packet in the resulting print. Your brain, however, would adjust this image, primarily because it would recognize it as being a building, but also because everything else would be in proportion. The building would still stand out and tower above its environment.

Similarly, you could photograph a king-size cigarette packet from a very low viewpoint so that it appeared to tower up like a skyscraper.

Using perspective

Choose a photograph from a newspaper or magazine and draw a carefully measured grid over it. Better still, draw 5mm or 10mm squares on a transparent material or tracing paper. You can then use the grid on any picture without damaging it. With the aid of this grid you will quickly learn how perspective works.

You will be able to see—because your grid has constant, equal squares—how objects steadily appear both narrower and less deep (smaller) as they stretch into the distance. You should also find where the horizon is situated, and thus be able to plot vanishing points.

This will help you notice the way three-dimensional scenes are depicted on the flat surface of a photograph or drawing. Try making better use of perspective as an element of design and composition in your pictures. The next section outlines a number of elements which will help you to create a sense of depth.

Incidentally, if you find yourself able to see the effect of perspective on the print but not through the camera, you might consider, if your camera has interchangeable focusing screens, using one with a squared grid. It may take a little time to get used to it, but you should see a big improvement in your pictures. If you revert to your original screen later, this improvement should remain.

▶ For this picture *Adam Woolfitt* has taken the trouble to find an unusual viewpoint which uses the effect of perspective to its greatest advantage. The flatness of the head-on view against the dynamic lines disappearing into the distance makes a striking contrast, emphasizing both elements.

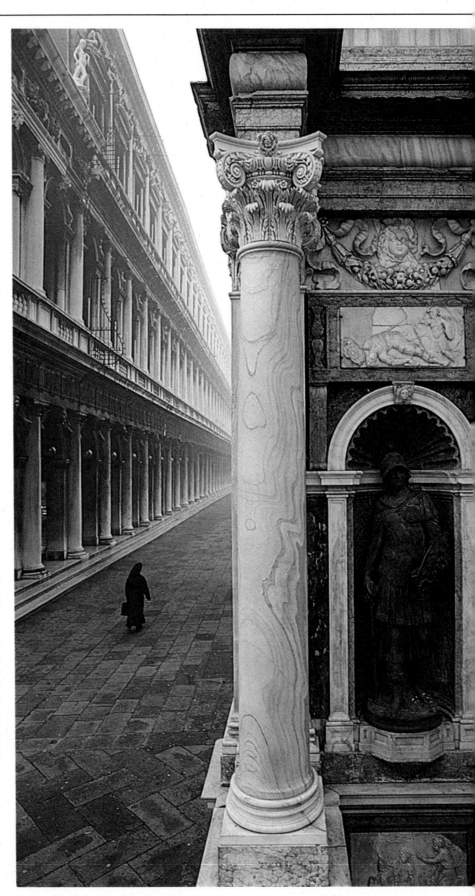

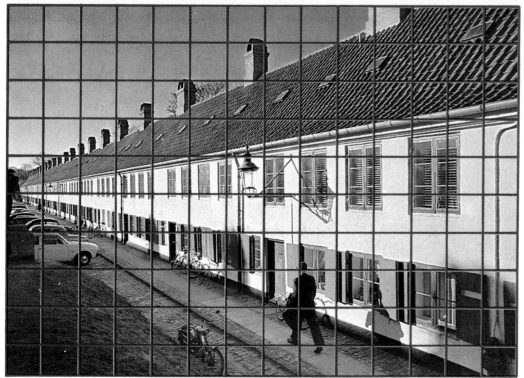

The essential part that perspective plays in giving a picture a sense of depth and distance is immediately obvious when looking at the print or transparency. It is not so easy to judge through the viewfinder. Placing a grid over printed photographs is one way of getting used to a squared focusing screen, which should help you over the problem. Even if you can't change the focusing screen on your camera you may find that this practice makes you think more carefully before you take your next picture.
Michael Busselle

Creating depth

A feeling of depth is not an essential requirement of every good photograph. A telephoto lens, for instance, compresses distance and can make an impressive two-dimensional picture which is immediately arresting because of its flatness—with the subject appearing to be on the *surface* of the photograph like a flat, drawn design instead of the usual 'window' on to a three-dimensional scene.

There are many subjects, however, where a flat image would be disappointing and where it is vital to create an impression of depth. Landscapes, for example, often appear to come to life only when the eye is drawn into and around the scenery, exploring the picture. Look at any number of successful photographs—still-lifes, landscapes or people—and notice how each composition benefits from having this strong 3-D effect.

So, one of the first decisions to consider every time you take a picture is: do you want to create a flat design or a 3-D effect?

There are a number of basic elements which can combine to give a sense of depth in a photograph: subject qualities such as scale, contour (i.e. overlapping forms), tone and texture. In addition there is the use of camera controls such as selective focusing. No matter whether you have a 110 or an SLR, you can exploit most of these to your own advantage. Start by looking for each individual element (described on the next four pages) in photographs in magazines and books. Then see if you can take shots based on one or several of these elements. As with other areas of composition the first step is to look carefully at the subject and recognize the opportunities.

▶ There are times, generally when the scene would otherwise be boring, when a flat, diagrammatic representation of a landscape can look very impressive. The strength of this picture, however, lies in its tremendous feeling of depth. The countryside seems to stretch on and on into the distance. *Kenneth Griffiths* has carefully composed the picture so that the eye is drawn from the foreground on the left, where every blade of grass is pin sharp, to the main subject on the right. The lines of the road then lead you into the middle distance, almost in the centre of the scene, and then on to the horizon. Including the low layer of cloud almost as a ceiling has further increased the sensation of depth.

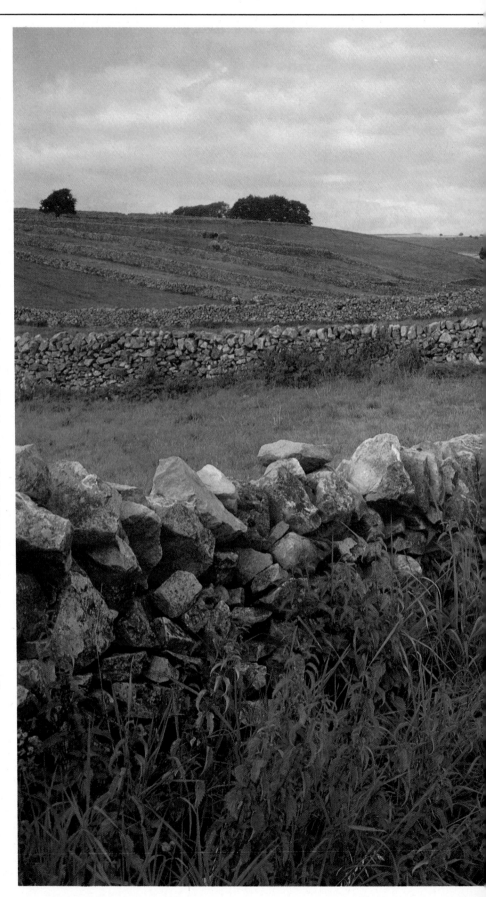

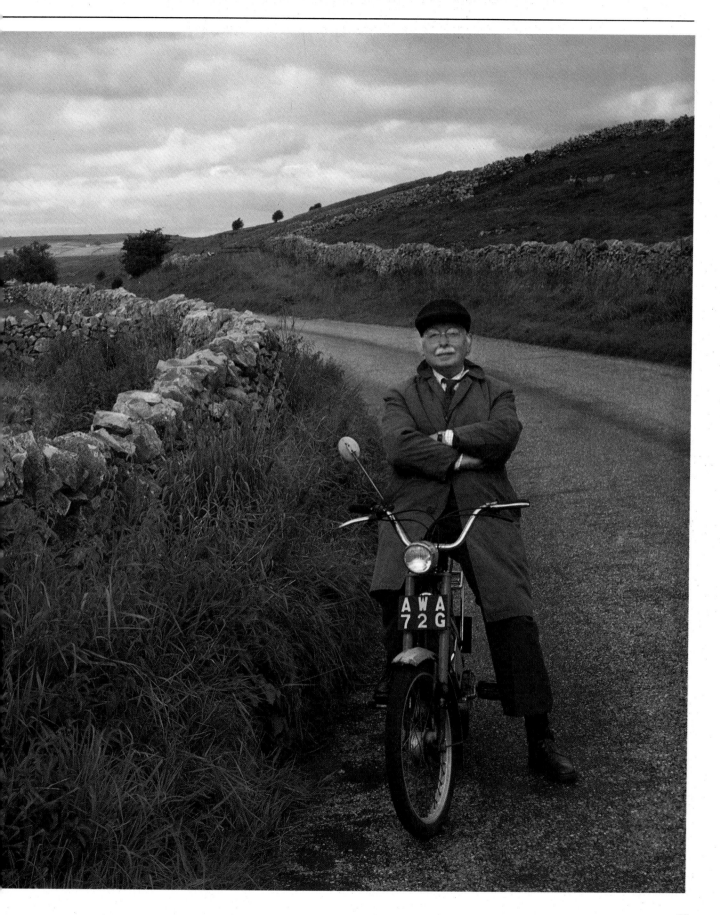

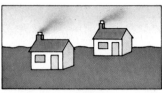

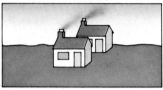

▶ SCALE: a picture which gives little indication of the scale of the elements within it can be very deceptive. Mountains, for example, may only look like small hills unless there is something in the picture to compare them with. Notice how the sense of distance in this picture depends to a great extent on the Eiffel Tower in relation to the figure in the foreground. When the tower is removed (see above) much of the feeling of depth goes with it. *Bryn Campbell*

▶ OVERLAPPING FORMS: when one element in the picture partially obscures another the overall impression of depth is far greater than if the two were some distance apart (this is illustrated by the simple diagrams above). The picture of the old abbey shows how the principle works in practice. Had the photographer moved closer, so that all of the abbey could be seen through the gap in the wall, the final picture would have lost depth and appear to be much flatter. *Clay Perry*

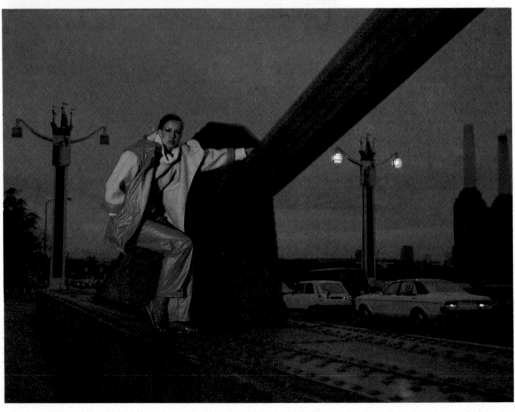

▶ LEAD-IN LINES: lines which draw the eye from the front of the picture into or around the main subject are a useful compositional device for inducing a feeling of depth. They can come from the bottom, the sides or, as in this picture, from the top. Compare this effect with that above where most of the railing has been cropped away. *Tino Tedaldi*

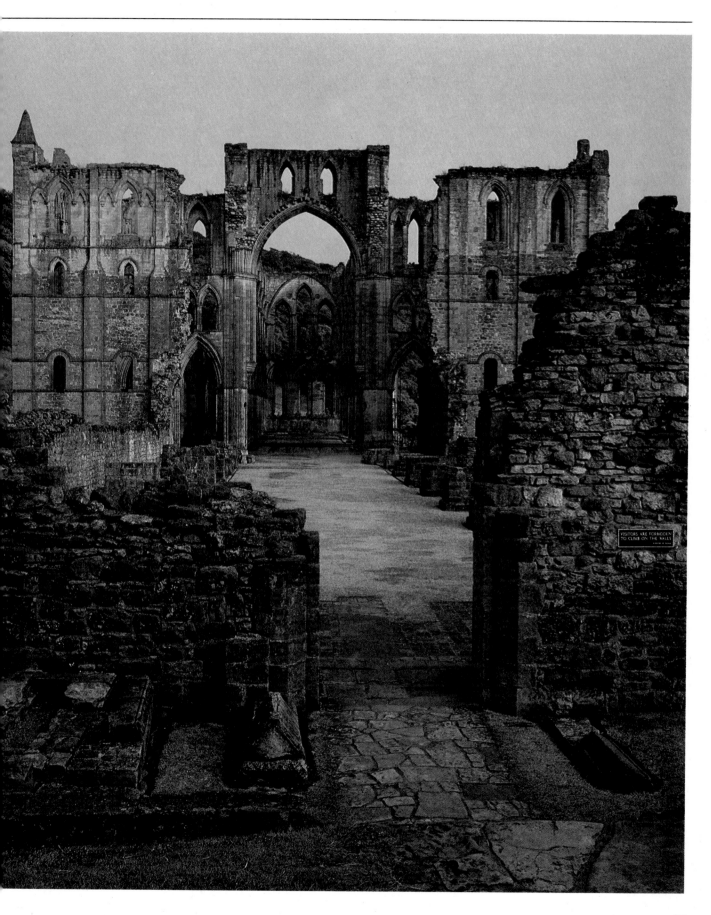

▶ **DIMINISHING SHAPES:** objects of the same or similar size appear to become smaller as they get further away (see diagrams above). *Robert Estall* has emphasized this for a greater feeling of depth in his picture by using a wide angle lens.

▲ **FILLING THE MID-GROUND:** choosing a view-point which places the main subject in the middle distance is an effective way of drawing the eye into a picture, so strengthening the feeling of depth. *John Goldblatt*

▲ **TEXTURE:** exaggerating the texture of foreground objects in contrast to the lack of detail in the distance is another method of adding to the feeling of depth in a photograph. Here it is obviously the converging lines of linear perspective which give the greatest sense of depth, but emphasizing the texture of the foreground by using a low viewpoint has also added to the effect. *Lisa Mackson*

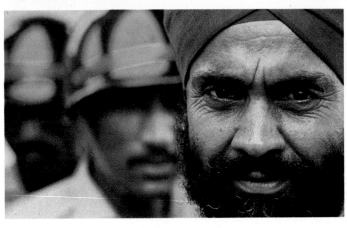

◀ **SELECTIVE FOCUS:** this technique is especially useful for producing depth in close-up shots and in subjects with a confused background. By throwing the background out of focus the sharp main subject stands out from the rest of the picture. The lack of detail in the background makes it seem to be further away from the main subject than it actually is, giving the illusion of depth.

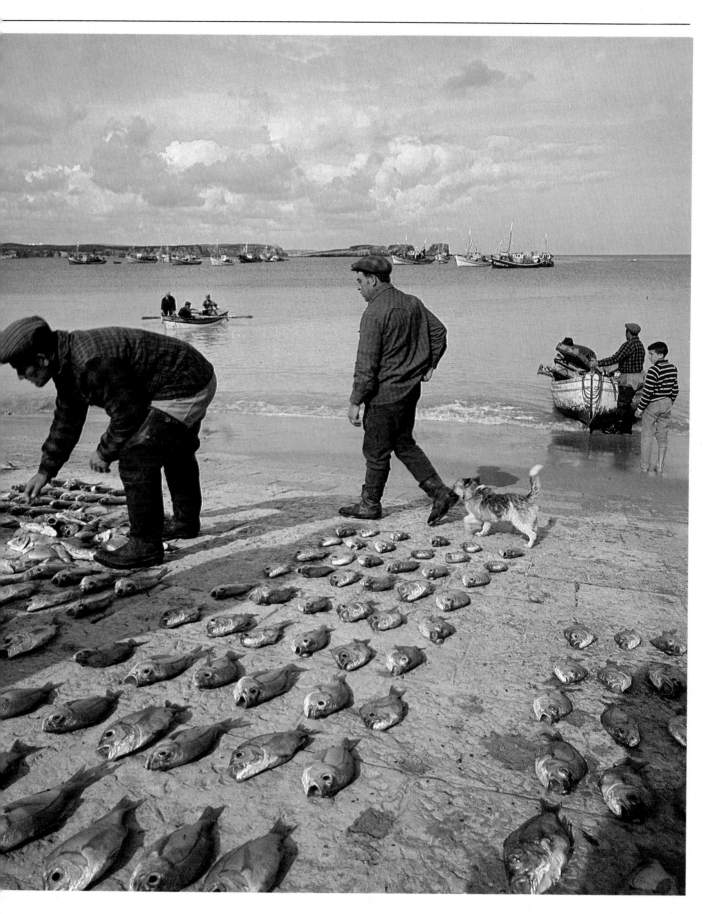

Exploiting depth of field

When taking a picture with anything but the simplest camera there are several decisions to be made before pressing the shutter: where to stand, what lens to use, which part of the subject to focus on, which speed and aperture to select. Each of these affects the final image in a different way, but all of them have a bearing on one very important aspect of photography—depth of field, or how much of the picture is sharply in focus.

Traditionally one of the hallmarks of a good photograph was that everything in the picture area was in sharp focus. In other words, good pictures had to have extensive depth of field. For certain subjects this is still true today, but it is now recognized that by varying the depth of field the emphasis in a picture can be altered, and this gives the photographer control over the way the subject is portrayed. With creative use of depth of field it is possible to manipulate the various elements of the composition.

The aperture

The simple way to increase or decrease depth of field is to change the size of the lens aperture. The smaller the aperture the greater the depth of field, and vice versa. As a rough guide, closing down two stops on any lens will double the depth of field.

Unfortunately, if you do stop down you have to use a slower shutter speed to compensate for the reduction of light. This may not always be convenient or even possible, particularly when you are hand-holding the camera. For example, if you are using a 135mm lens and hand-holding the camera it is advisable to avoid shutter speeds slower than 1/125 if you want to eliminate camera shake. In this case even on a reasonably bright day, with 64 ASA film you will only have a choice of apertures down to f5·6. You then either have to accept limited depth of field or place the camera on a tripod.

Interchangeable lenses

The most radical way to change the depth of field is to change the lens, if your camera has that facility. Almost every 35mm camera of the single lens reflex type allows you to change lenses easily and to see the result of doing so clearly in the viewfinder.

The relationship between depth of field and the focal length of the lens with interchangeable lens cameras is simple. The shorter the focal length, the greater the depth of field for any given

▼ These pictures were all taken with a 50mm lens, focused on the queen. The aperture was stopped down successively from f2 (A) to f5·6 (B) to f16 (C). The effect of stopping down on the depth of field is considerable, and most noticeable in the background and the edge of the board at the front.

▲ The longer the lens the shallower the depth of field is likely to be. For this shot *Ed Buziak* used a 300mm telephoto lens at an aperture of f5·6 and the depth of field is extremely limited. If you look closely at the sand you will see that only a narrow stretch level with the chair is sharp.

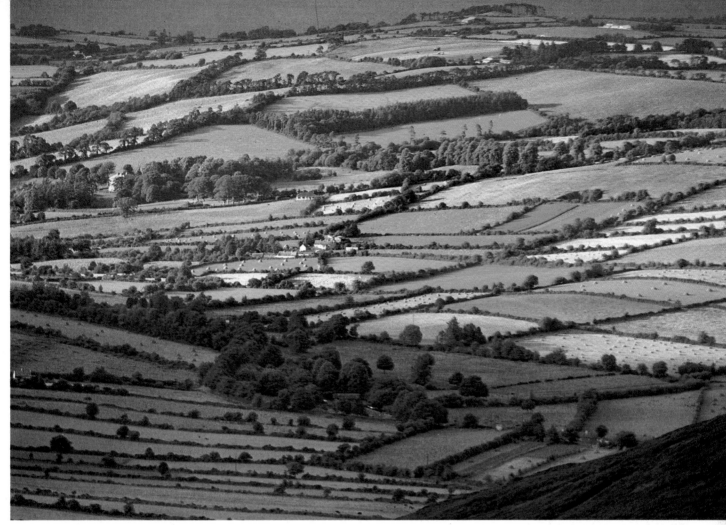

▲ The farther the subject is from the camera the greater the depth of field—even when using a fairly long lens. When taking this picture *Adam Woolfitt* was on a hill about 500 metres away. He used a 200mm lens and an aperture of f8, but because he was so far away everything in the picture is sharp.

aperture at a given distance. For example, if you are using a 35mm camera with a standard 50mm lens, focusing on a subject four metres away will give a depth of field of almost half a metre behind and in front of the subject at an aperture of f5·6. If, however, you focus on the same spot with a 200mm lens the depth of field at f5·6 will be no more than 10cm, which is about the thickness of your arm.

If your camera has a depth of field preview facility, you can check this visually, to some extent.

Camera-to-subject distance

The farther you are from the subject on which you are focusing, the greater the depth of field. With the standard lens a distant view—a valley seen from a hilltop, for example—will show everything in focus, unless you try to include close foreground detail as a frame for the picture. For a portrait, however, you will have to get closer to the subject to fill the frame, and this will give a much shallower depth of field.

Trying out alternatives

As already mentioned, one of the important advantages of many SLR cameras is that you can preview the result of changing lens and aperture and see how the depth of field is

affected in the viewfinder.

Set yourself an exercise. Select a subject that is either static or easy to control, such as a receding landscape or a still life. (Make sure that the light is quite bright or you will not be able to see the subject clearly in the viewfinder as you stop down to the smallest apertures.) Now try out all the alternative combinations of apertures and lenses and see the effects that you get and which subjects they suit best.

Once you are familiar with these you will find it useful to expose some film at each aperture, varying the shutter speed to keep the exposure constant. You will then be able to study the effects of a change in depth of field in greater detail.

Shallow depth of field

This is used to isolate objects or people from their surroundings. The subject, which is sharply focused, contrasts strongly with the background which is out of focus. It is most commonly used in photographing small objects, such as flowers, where the natural background of the subject is often confusing.

Using a shallow depth of field is also a particularly effective way of drawing attention to one person in a crowd or street scene. It helps to isolate an expression or gesture that would

Hyperfocal distance

The hyperfocal distance is the nearest point of sharpness from the camera when the lens is focused on infinity. This applies to any lens at any aperture, and it provides an almost fail-safe method of obtaining maximum depth of field. The calculations necessary to determine the hyperfocal distance are complex and need not concern us here. The short-cut method is to actually read it off the lens.

If you first focus on infinity (∞) at a given aperture, depth of field extends from the 'near limit' of sharpness to infinity. The near limit, indicated on the lens depth of field scale, is also the hyperfocal distance (see diagram A). If you then turn the focusing ring so that the lens is focused on the hyperfocal distance (diagram B) infinity will now coincide with the 'far limit' on the depth of field scale. The near limit will show that depth of field now extends much nearer the camera.

By focusing on the hyperfocal distance therefore you obtain the maximum possible depth of field for the given lens at a chosen aperture.

otherwise be lost in a mass of detail. In such circumstances great care is needed with focusing.

Although the background is out of focus when using shallow depth of field it does not mean that you can therefore disregard it entirely. Strong colours or highlights can be just as intrusive when blurred as they are when sharply in focus. So, take care with choice of viewpoint even when using differential focus.

Extensive depth of field

When the whole of the image is sharply focused a completely different approach to composition is necessary. When using a shallow depth of field the composition is largely created in the camera. When the entire image is sharp, however, the lines and shapes of the scene dictate the content of the picture. Instead of manoeuvering round an object you will need to place your camera precisely in relation to the subject. The frame must be used to eliminate unwanted objects and distracting detail.

The fineness of detail recorded through-

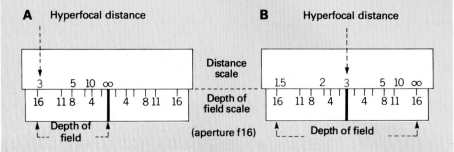

A Hyperfocal distance

B Hyperfocal distance

(aperture f16)

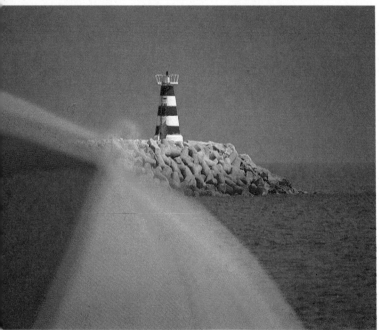

▲ To throw the umbrella out of focus and emphasize the lighthouse *Raul Constancio* needed limited depth of field. As the light was too bright for a wide aperture he had to use a long lens. He chose a 500mm mirror lens with a fixed aperture of f8.

▶ The beauty of shallow depth of field is that it can be used to isolate part of the picture very precisely, even if the background is much the same colour as the subject as it is here. For this shot *Graeme Harris* used an aperture of f2.

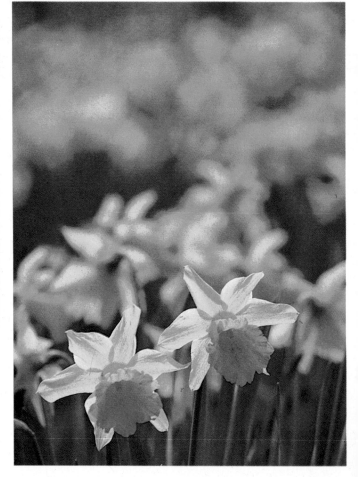

out the image will allow you to use textures and shapes in a more subtle way than with shallow depth of field. Rounded stones can be contrasted with slender, spiky patches of grass, for example; or the solid, regular shape of a building can be used to counterpoint the fine tracery of some leafless trees. Portraits take on a different dimension when using an extensive depth of field. Instead of concentrating on the lines and features of the face, the person can be photographed in an appropriate environment. A gardener can be posed against a background of his favourite flowers, for instance. Of course care must be taken to avoid confusion, and the details of the surroundings will need to be well organized to complement the central character.

To sum up

With interchangeable lens cameras as normally used, the following rules will enable you to control depth of field:
● Short focal length lenses give more depth of field than long lenses.
● Any lens has more depth of field when focused at greater distances from the camera.
● Any lens has greater depth of field when stopped down to a smaller aperture.
● To maximize depth of field use the hyperfocal distance when focusing.
Therefore if you need more depth of field you can use a smaller aperture, move back, or change to a shorter focal length lens. If you want less depth of field you can do the reverse in each case: use a larger aperture, move closer to the subject, or change to a lens of longer focal length.

If you want everything in the picture to be sharp, follow the rules for larger depth of field, but take extra care with the composition. If you want to separate the subject from the background to give it more emphasis, follow the rules for narrow depth of field, but remember that the subject itself must be interesting enough to stand on its own.

▶ The creative use of shallow depth of field is known as differential, or selective, focus. The photographer selects which part of the picture will be in focus and will therefore be the most visible. By using a telephoto lens for this shot, *Nigel Snowdon* has not only managed to separate his subject from a confused background but also to get a close-up without disrupting the action.

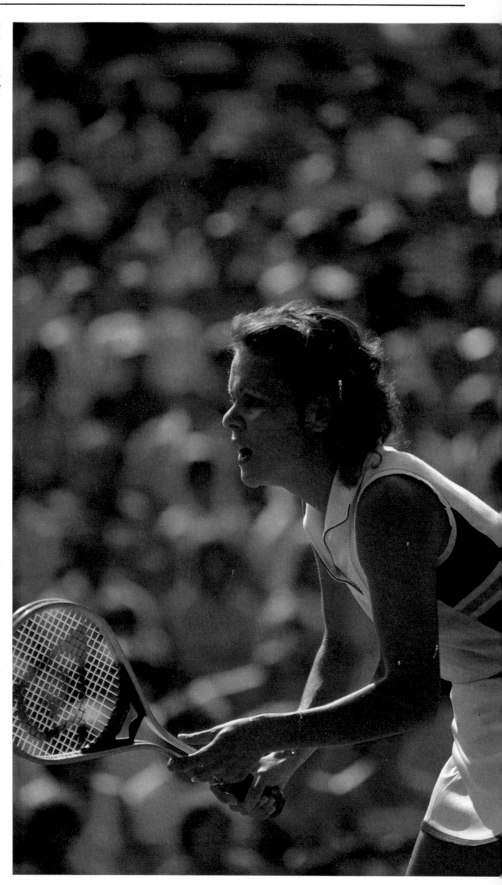

Abstract images

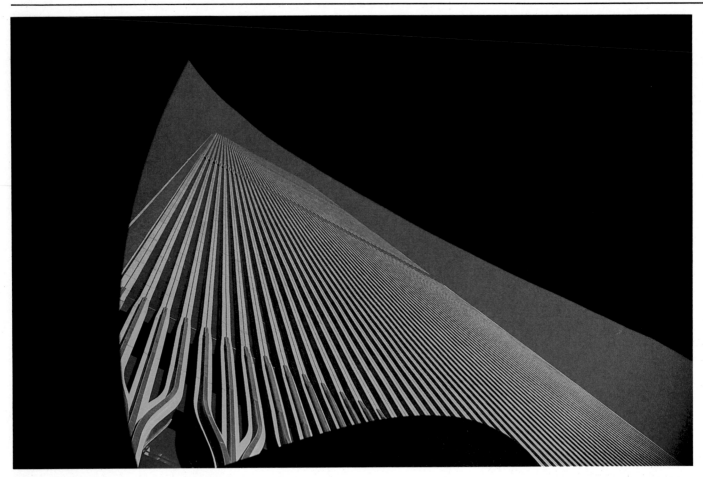

One of the most widely held beliefs about photography is that the camera cannot lie. This belief is so strong that we are often shocked or surprised when a subject in reality does not match up to its image on a photograph, and vice versa. In actual fact the camera does not lie, but there are various compositional devices which can be employed to make the camera appear to 'exaggerate' reality slightly. These are especially useful when it comes to taking abstract pictures.

Most photographers, like painters, want to do more than just record reality. They want to express their personal feelings and place a particular interpretation upon what they see—to explore the medium and not be governed by rules and conventions. By breaking the rules, or by using them in a new way, the photographer begins to become creative. One of the most rewarding areas of creative photography is the making of abstract or semi–abstract images.

This section deals with creating abstract pictures by exploiting the basic elements of composition—viewpoint, perspective, pattern, shape and move-ment. You an also create abstract images in other ways: by using special lenses, multiple exposures and unusual films and filters.

Viewpoint

Generally, photographs are taken from eye level. This is mainly due to the popularity of the eye–level SLR and rangefinder cameras. However, viewpoint is one of the most flexible aspects of composition, and by altering the viewpoint you can dramatically change the whole meaning of the picture.

When composing an abstract picture the choice of viewpoint is of paramount importance. By moving higher or lower, closer to or farther from the subject you alter scale and perspective and can rearrange the original subject in a way that seems more visually interesting. With close–ups especially you can remove a tiny part of a subject from the rest of the scene, or isolate a small but dominant area of colour so that the subject becomes unrecognizable.

This technique is often used in television panel games, where the contestants are shown an enlarged picture of a small fragment of an everyday

▲ **An unusual viewpoint can transform an ordinary subject into an abstract image. For this shot of the World Trade Center in New York *Richard Laird* chose a low viewpoint with unusual framing through a foreground object.**

▶ **By breaking the accepted rules of composition and dividing his picture almost in half diagonally, *Ed Buziak* has made the simple subject of a hedge-lined path nearly unrecognizable.**

object and required to guess the identity of the whole object. The enlargement is basically an abstract.

Alternatively, a subject can form an abstract image from a very distant viewpoint. A landscape taken from an aeroplane, for instance, can appear so diminished in scale that it is reduced to an abstract series of lines and patterns.

Perspective

Perspective and viewpoint are almost inseparably linked. The effect of linear perspective depends entirely on the viewpoint—a close viewpoint will exaggerate perspective, a more distant viewpoint will diminish the effect.

▲ Balls in a bowling alley? Crash helmets? By excluding familiar elements from the picture area *John Sims* has disguised the scale of the objects in this composition and so created a totally abstract image of strong colour and line.

▶ An abstract picture usually works best when the colours and shapes are kept as simple as possible. A close viewpoint, used here by *Ed Buziak* for an abstract of a wall painting, helps to exclude distracting detail and give the colours impact.

Exaggerating perspective by using a low, close viewpoint can produce spectacular or wierd abstract images. The effect of aerial perspective, too, can be exaggerated to produce the familiar cardboard cut–out images of a series of hills. Here, a long focus lens will help add to the abstract effect by compressing the distance.

Pattern

Pattern is the orderly or disorderly arrangement of elements, natural or man–made, into some form of repe- tition. It can be two–dimensional, as in brickwork or a cross–section of a piece of timber, or it can be three– dimensional where light and shadow reveal a texture or repetitive shape.

For abstract pictures pattern can be explored from all angles and distances. Its abstraction is apparent in itself when isolated from other non–patterned elements or when put into contrasting situations with other repetitive forms.

Care should be taken when creating abstracts from patterns. Too much of the same pattern can look monoton- ous, so good, tight framing will usually be needed, coupled with a close viewpoint.

Shape

Normally it is the shape of a subject which enables us to recognize it. Ab- stract pictures can be made by either disguising or distorting a previously recognizable shape by the choice of an unusual viewpoint.

Reflections, shadows or refraction through glass can also make interesting abstract shapes.

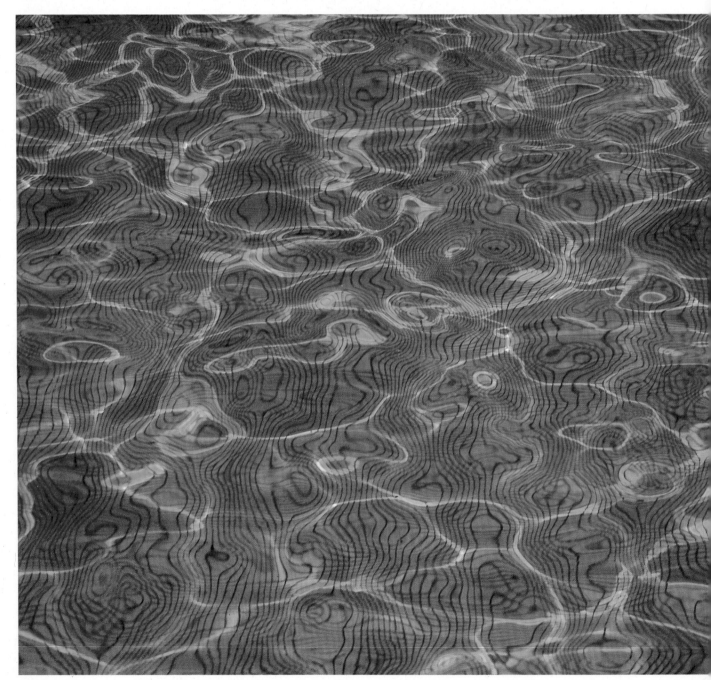

▼ Pattern is one of the most natural subjects for abstract pictures; and light is a vital element in the formation of pattern. This abstract picture by *Adam Woolfitt* is simply the pattern created by refracted light from the surface of water in a swimming pool.

▲ A break in the pattern can add an important element of variety to an abstract picture, especially if the colours are subdued as they are here. For this picture *Michael Busselle* chose a point in the line of tiles where the rhythm was disturbed.

Above right: Shape can be disguised by careful framing. This bold abstract image was also helped by strong, flat lighting on the building's surface. *Anne Conway*

▲ Reflection and the repetition of colours gives this picture its abstract quality. Had the van been blue, for example, the composition would have assumed a greater sense of reality. *Ed Buziak*

◄ The shapes and pattern formed by shadows are often a good subject for abstract pictures. This is especially true when all detail in the shadow areas is lost and only the shapes remain.

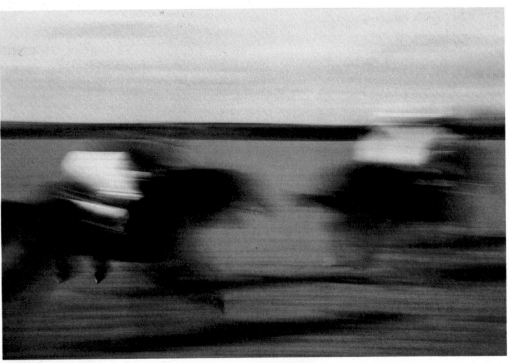

▲ Panning the camera with a moving subject can create an abstract image. Pan at the same speed as the subject and only the background becomes an abstract blur. Pan faster, or slower, then both subject and background become blurred, the whole image forming an abstract of lines in the direction of the pan. *Richard Tucker*

◄ Straight movement of the camera, even if the subject is static, will produce a strongly linear abstract.

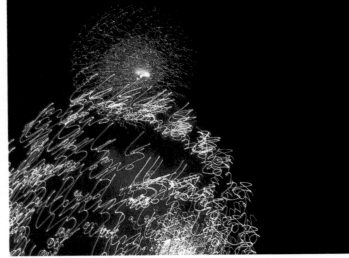

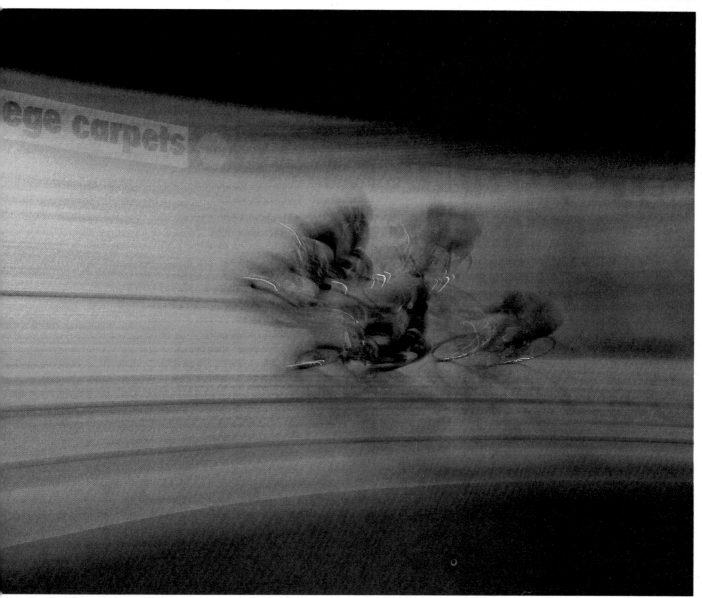

▲ A certain amount of abstraction is helpful when trying to convey the impression of speed, but it is useful to retain some degree of reality if the subject is to remain recognizable. Note how the parts of the subject which move in a different direction from the camera, the wheels in this instance, make a separate abstract pattern.

◄ In the same way that moving lights will record an abstract pattern during a long exposure while the camera is on a tripod, a moving camera will give an abstract image of static lights. Here *Ed Buziak* shook the camera about during an exposure of several seconds. Every tiny light has traced out the same pattern, following exactly the movement of the camera.

Movement

Photography is usually concerned with the taking of sharp, frozen pictures of subjects, many of which move. Using movement in abstract photography is concerned with the opposite effect, that of creating and controlling blurred images. This is done either by moving the camera or by choosing a moving subject, or both, while giving a long exposure time.

There is almost no limit to the abstraction that can be created by image blur, but a certain amount of experimenting needs to be done first. Start simply, and then move on to more complicated images as you become more confident. Remember, too much movement will result in confusion, so don't go too mad. Also, don't keep the

shutter open for too long—lengthy exposures can over–expose bright lights and wash out the colours.

Daytime colour blur is easily practised with slow film and slow shutter speeds, combined with a small aperture. Use a neutral density filter if necessary. Ordinary crowded streets can become a wonderful blur of colour, rivalling carnival processions; a horse race can form a simple abstract of straight lines. As a rule, daylight abstracts of movement are most suitable for colour film. The contrast is not normally great enough for black and white. At night, however, either colour or black and white are suited to making abstract pictures of lights. Neon lights especially create a good effect, because of their intensity.

Glossary

Words in *italics* appear as separate entries.

A

Angle of view This is the maximum angle seen by a lens. Most so-called standard or normal lenses (for example 50mm on a 35mm camera) have an angle of view of about 50°. Lenses of long focal length (200mm for example) have narrower angles and lenses of short focal length (eg 28mm) have wider angles of view.

Aperture The opening within a camera lens system that controls the brightness of the image striking the film. Most apertures are variable—the size of the film opening being indicated by the f number.

Artificial light This term usually refers to light that has specifically been set-up by the photographer. This commonly consists of floodlights, photographic lamps, or flash light (electronic or bulb).

ASA American Standards Association. The relative sensitivity of light to a film (often called film speed) can be measured by the ASA standard or by other standards systems, such as DIN. The ASA film speed scale is arithmetical—a film of 200 ASA is twice as fast as a 100 ASA film and half the speed of a 400 ASA film.

Automatic exposure A system within a camera which automatically sets the correct exposure. There are three main types:
1 Aperture priority—the photographer selects the aperture and the camera selects the correct shutter speed.
2 Shutter priority—the photographer selects the shutter speed and the camera sets the correct aperture.
3 Programmed—the camera sets an appropriate shutter speed/aperture combination according to a pre-programmed selection.

Available light A general term describing the existing light on the subject. It normally refers to low levels of illumination—for example, at night or indoors. These conditions usually require fast films, lenses of large aperture—for example, f2—and relatively long exposure times.

B

Bracketing To make a series of different exposures so that one correct exposure results. This technique is useful for non-average subjects (snowscapes, sunsets, very light or very dark toned objects) and where film latitude is small (colour slides). The photographer first exposes the film using the most likely camera setting found with a light meter or by guessing. He then uses different camera settings to give more and then less exposure than the nominally correct setting. Examples of bracketing are 1/60th sec f8, 1/60th sec f5·6, 1/60th sec f11, *or* 1/60th sec f8, 1/30th sec f8, 1/125th sec f8.

C

CC filters These are 'colour correcting' or 'colour compensating' filters which may be used either in front of the camera or when printing colour film, to modify the final overall colour of the photograph. Their various strengths are indicated by numbers usually ranging from 05 to 50. Filters may be combined to give a complete range of colour correction.

Contrast The variation of image tones from the shadows of the scene, through its mid-tones, to the highlights. Contrast depends on the type of subject, scene brightness range, film, development and printing.

Conversion filter Any filter which converts light from one standard source to the colour of light from another standard source. For example, a Wratten 85B filter converts daylight to the colour of photoflood illumination. This filter, when placed in front of the camera lens, enables a camera loaded with tungsten colour film to give correct colour photographs in daylight. To compensate for the light absorbed by the filter, it is necessary to give extra exposure. This is determined by the filter factor.

D

Daylight colour film A colour film which is designed to be used in daylight without or with electronic flash or blue flash-bulbs. This film type can also be used in tungsten or fluorescent lighting if a suitable filter is put in front of the lens or light source.

Depth of field The distance between the nearest and furthest points of the subject which are acceptably sharp. Depth of field can be increased by using small apertures (large f numbers), and/or short focal-length lenses and/or by taking the photograph from further away. Use of large apertures (small f numbers), long focal-length lenses, and near subjects reduces depth of field.

Depth of field preview A facility available on many SLR cameras which stops down the lens to the shooting aperture so that the depth of field can be seen.

DIN Deutsche Industrie Normen. A film speed system used by Germany and some other European countries. An increase/decrease of 3 DIN units indicates a doubling/halving of film speed, that is a film of 21 DIN (100 ASA) is half the speed of a 24 DIN (200 ASA) film, and double the speed of an 18 DIN (50 ASA) film. See also *ISO*.

E

Emulsion speed See *ASA, ISO* and *DIN*.

Exposure The result of allowing light to act on photosensitive material. The amount of exposure depends on both the intensity of the light and the time it is allowed to fall on the sensitive material.

Exposure meter An instrument which measures the intensity of light falling on (incident reading) or reflected by (reflected reading) the subject. Exposure meters can be separate or built into a camera, the latter type usually gives a readout in the viewfinder and may also automatically adjust the camera settings to give correct exposure.

F

Fast films Films that are very sensitive to light and require only a small exposure. They are ideal for photography in dimly lit places, or where fast shutter speeds (for example, 1/500) and/or small apertures (for example, f16) are desired. These fast films (400 ASA or more) are more grainy than slower films.

Film speed See *ASA, ISO* and *DIN*.

Filter Any material which, when placed in front of a light source or lens, absorbs some of the light coming through it. Filters are usually made of glass, plastic, or gelatin-coated plastic and in photography are mainly used to modify the light reaching the film, or in colour printing to change the colour of the light reaching the paper.

Flare A term used to describe stray light that is not from the subject and which reaches the film. Flare has the overall effect of lowering image contrast and is most noticeable in the subject shadow areas. It is eliminated or reduced by using coated lenses (most modern lenses are multi-coated), lens hoods and by preventing lights from shining directly into the lens.

f numbers The series of internationally agreed numbers which are marked on lenses and indicate the brightness of the image on the film plane—so all lenses are focused on infinity. The f number series is 1·4, 2, 2·8, 4, 5·6, 8, 11, 16, 22, 32 etc—changing to the next largest number (for example, f11 to f16) decreases the image brightness to ½, and moving to the next smallest number doubles the image brightness.

Focal length The distance between the optical centre of the lens (not necessarily within the lens itself) and the film when the lens is focused on infinity. Focal length is related to the angle of view of the lens—wide-angle lenses have short focal lengths (for example 28mm) and narrow-angle lenses have long focal lengths (for example, 200mm).

Focal plane The plane behind the lens that produces the sharpest possible image from the lens—any plane nearer or farther from the lens produces a less sharp image. For acceptable results the film must be held in the focal plane.

Focal plane shutter A shutter that is positioned just in front of the film (focal plane). The exposure results from a slit travelling at constant speed across the film—the actual shutter speed depending on the width of the slit. As a focal plane shutter is built into the camera body, it is not necessary for lenses to incorporate shutters.

Focusing The act of adjusting the lens-to-film distance so that the subject is sharply focused. This is achieved by rotating the lens focusing ring or by sliding the lens or film panel backwards or forwards.

Focusing screen A ground glass screen on to which the image is focused. Focusing screens may also incorporate a variety of focusing aids; a split-image rangefinder or microprism rangefinder, for example. Some cameras have screens that can be interchanged with others, according to the subject matter and the preference of the photographer.

Format Refers to the size of image produced by a camera, or the size of paper and so on.

G

Gradation The range of tones, from white through to black, in a print or negative and how these tones relate to one another. For example, a long soft gradation indicates a large range of tones that gradually change from one to the next.

Grain The random pattern within the photographic emulsion that is made up of the final (processed) metallic silver image. The grain pattern depends on the film emulsion and development.

Grey scale A series of grey patches joined together ranging from white through light, mid and dark greys, to blacks. Usually the differences between adjoining patches are either visually equal or are of equal density increments (eg. 0, 0.3, 0.6, 0.9 etc). Grey scales are very useful for detecting contrast and colour changes.

H

Hue The colour of an object is described in terms of its brightness (light or dark), saturation (purity), and hue—the hue being the colour name, for example, red, blue, green.

Hyperfocal distance A lens that is focused on the hyperfocal distance produces acceptably sharp images of objects that are positioned between infinity and half the hyperfocal distance. Hyperfocal distance depends on the lens aperture, lens focal length, and the film format. For example, a 50mm lens on a 35mm camera set at f8 has a hyperfocal distance of 33 ft (10m) and produces sharp images of objects between infinity and 16½ ft (5m).

I

Interchangeable lens A lens which can be detached from the camera body and replaced by another lens. Each camera manufacturer has its own mounting system (screw thread or bayonet type) which means that lenses need to be compatible with the camera body. However, adaptors are available to convert one type of mount to another.

ISO International Standards Organization. The ISO number indicates the film speed and aims to replace the dual ASA and DIN systems. For example, a film rating of ASA 100, 21 DIN becomes ISO 100/21°.

L

Leaf shutter A type of lens shutter which is usually built into a lens and operates by several metal blades opening outwards to reveal the diaphragm aperture and then closing when the exposure time is completed. Leaf shutters have the advantage of being able to synchronize with flash at any speed but only have a top speed of 1/500 second.

Lens An arrangement of shaped glass or plastic elements which produces an image of a subject.

Lens hood (shade) A conical piece of metal, plastic or rubber which is clamped or screwed on to the front of a lens. Its purpose is to prevent bright light sources, such as the sun, which are outside the lens field of view from striking the lens directly and degrading the image by reducing contrast (flare).

Long focus lens Commonly used slang for 'long focal length lens', which means any lens with a greater focal length than a standard lens, for example, 85mm, 135mm and 300mm lenses on a 35mm camera. These long focal length lenses are ideal for portraiture, sports and animal photography.

M

Mirror lens Any lens which incorporates mirrors instead of conventional glass (or plastic) lens elements. This type of lens design is employed mainly for long focal length lenses (eg 50mm), and produces a relatively lightweight lens with a fixed aperture (about f8).

N

Normal lens A phrase sometimes used to describe a 'standard' lens—the lens most often used, and considered by most photographers and camera manufacturers as the one which gives an image most closely resembling normal eye vision. The normal lens for 35mm cameras has a focal length of around 50mm.

O

Over-exposure Exposure which is much more than the 'normal' 'correct' exposure for the film or paper being used. Over-exposure can cause loss of highlight detail and reduction of image quality.

P

Panchromatic emulsion An emulsion which is sensitive to UV, and all visible light. Most black-and-white films designed for use in the camera are panchromatic.

Panning The act of swinging the camera to follow a moving object to keep the subject's position in the viewfinder approximately the same. The shutter is released during the panning movement.

Pentaprism An optical device, used on most 35mm SLR cameras, to present the focusing screen image right way round and upright.

Pushing a film See *Uprating a film*.

S

Sharpness The subjective evaluation of how clearly line detail is recorded.

Short focus lens A slang term meaning short focal-length lens.

Shutter The device which controls the duration of exposure. See *Focal plane shutter and Leaf shutter*.

Single lens reflex (SLR) A camera which views the subject through the 'taking' lens via a mirror. Many SLRs also incorporate a *pentaprism*.

Skylight filter A filter which absorbs UV light, reducing excessive blueness in colour films and removing some distant haze. Use of the filter does not alter camera settings that is, filter factor x1.

Soft-focus lens A lens designed to give slightly unsharp images. This type of lens was used primarily for portraiture. Its results are unique and are not the same as a conventional lens defocused or fitted with a diffusion attachment.

Standard lens See *Normal lens*.

Stop Another term for aperture or exposure control. For example, to reduce exposure by two stops means to either reduce the aperture (for example, f8 to f16) or increase the shutter speed (1/60 sec to 1/250 sec) by two settings. To 'stop down' a lens is to reduce the aperture, that is, increase the f-number.

Stopping down The act of reducing the lens aperture size ie, increasing the f-number. Stopping down increases the depth of field and is often used in landscape and advertising work, where sharp detail is needed over all the subject.

T

Telephoto lens A long focal-length lens of special design to minimize its physical length. Most narrow-angle lenses are of telephoto design.

Tonal range The comparison between intermediate tones of a print or scene and the difference between the whitest and blackest extremes.

Tungsten film Any film balanced for 3200K lighting. Most professional studio tungsten lighting is of 3200K colour quality.

Tungsten light A light source which produces light by passing electricity through a tungsten wire. Most domestic and much studio lighting uses tungsten lamps.

Twin lens reflex (TLR) A camera which has two lenses of the same focal length—one for viewing the subject and another lens for exposing the film. The viewing lens is mounted directly above the taking lens.

Type B colour film Former name for *tungsten film*.

U

Underexposure Insufficient exposure of film or paper which reduces the contrast and density of the image.

Uprating a film The technique of setting the film at a higher ASA setting so it acts as if it were a faster film but is consequently underexposed. This is usually followed by overdevelopment of the film to obtain satisfactory results.

V

Variable focus lens Slang term for a lens having a range of focal lengths. See *Zoom lens*.

Viewfinder A simple device, usually optical, which indicates the edges of the image being formed on the film.

Viewpoint The position from which the subject is viewed. Changing viewpoint alters the perspective of the image.

W

Wide-angle lens A short focal-length lens which records a wide angle of view. It is used for landscape studies and when working in confined spaces.

Z

Zoom lens Alternative name for a lens having a range of focal lengths. One zoom lens can replace several fixed focal lenses.

Index

Photographic credits

Ardea Photographics 57 (top right)
Stephen Ballantyne/Eaglemoss 15 (right)
Bruno Barbey/Magnum 38, 52
Colin Barker 7 (left), 57 (centre right), 61 (bottom left)
Colin Barker/Eaglemoss 15 (top left and bottom left), 17 (top)
Jonathan Bayer 67 (top right)
Michael Boys/Susan Griggs Agency 42
John Bulmer 12 (top right and bottom), 20, 21 (bottom right), 24 (top), 26 (top), 43 (top) 73 (bottom left)
Michael Busselle 31 (top left and top right), 40 (top), 43 (bottom), 47, 48 (bottom), 49, 51, 53, 56 (centre right, bottom left and bottom right), 57 (top left and centre left), 61 (top left, top right and bottom right), 63 (bottom right), 64 (top), 66 (top), 67 (bottom right), 69 (top right and bottom), 70, 77, 91 (top left)
Michael Busselle/Eaglemoss 65 (top and bottom right)
Ed Buziak 84 (top), 89 (top right and bottom), 91 (centre and bottom), 92 (bottom right), 93
Bryn Campbell/John Hillelson Agency 25
Bryn Campbell 80 (top left and top right)
Bill Colman 28, 30 (bottom left and bottom right), 62, 63 (left)
Raul Constancio 86 (left)
Anne Conway 33, 91 (top right)
Cressida 57 (bottom right)
Eric Crichton 22 (bottom), 56 (top), 59 (bottom), 61 (centre)
Malcolm Crowthers 35 (top right, centre and bottom)
Tony Duffy/All-Sport 40 (bottom)
Michelangelo Durazzo/Magnum 55 (top)
Robert Eames 92 (bottom left)
Robert Estall 22 (top), 83

Gordon Ferguson 41, 50 (bottom)
Paul Forrester 59 (top)
Jon Gardey/Robert Harding Agency 19
Georg Gerster/John Hillelson Agency 54
Mario Giacomelli 36, 37
John Goldblatt 82 (right)
Alfred Gregory 48 (top)
Kenneth Griffiths 78, 79
Graeme Harris 86 (right)
Tessa Harris 34
Gunter Heil/ZEFA 68 (top), 69 (top left)
Steve Herr/Vision International 72
Suzanne Hill 55 (bottom), 56 (centre left)
Thomas Höpker/Magnum 29 (bottom)
David Hurn/Magnum
Karsh/Camera Press 63 (top)
Bob Kauders 67 (top left)
Ken Kirkwood/Eaglemoss 8, 9
Paolo Koch/Vision International 73 (top)
Richard Laird/Susan Griggs Agency 88
Robin Laurance 21 (bottom left), 66 (bottom)
Barry Lewis 13, 21 (top)
Barry Lewis/Eaglemoss 10, 11
Lisa Mackson 73 (bottom right), 82 (top left)
Don McCullin/Magnum 71
Roland Michaud/John Hillelson Agency 26 (bottom)
Peter Myers 44 (top)
Mike Newton 58, 68 (bottom left and bottom right), 75 (bottom)
Martin Parr 23
Clay Perry 81
Van Phillips 35 (top left)
Spike Powell 12 (top left), 44 (bottom right)
George Rodger/Magnum 44 (bottom left), 45, 50 (top), 60
Tina Rogers 84 (bottom), 85 (bottom)
Clive Sawyer/ZEFA 75 (top)
Chris Schwarz/Mudra Documentaries 31 (bottom)

Tomas Sennett/John Hillelson Agency 17 (bottom), 27 (top), 29 (top left), 82 (bottom left)
John Sims 89 (top left)
Chris Smith 46 (bottom)
Nigel Snowdon 87
Eric Stoye 24 (bottom)
Homer Sykes 14
Homer Sykes/Eaglemoss 16
Tino Tedaldi 80 (bottom left and bottom right)
Patrick Thurston 18, 32
Patrick Thurston/Woodfin Camp 46 (top)
Richard Tucker 67 (bottom left), 92 (top)
John Walmsley 30 (top left and top right)
Patrick Ward/Time Life International (Nederland) B.V. from 'The Great Cities Series' 27 (bottom)
William Wise 29 (top right)
Adam Woolfitt/Susan Griggs Agency 76, 85 (top), 90
Herbie Yamaguchi 64 (bottom), 65 (bottom left)
ZEFA 6, 7 (right)

Artwork credits

Jim Bamber 24, 25
Drury Lane Studios 73, 74, 80, 82
Coral Mula 9

Editorial credits

The Consultant Editor Christopher Angeloglou is an Assistant Editor of *The Sunday Times* and was the first Editor of *You and Your Camera*. He worked as a photographer on *The Sunday Times Colour Magazine* when it first started and later became The Picture Editor.

Contributors: Michael Busselle, Ed Buziak, Laurence Esher, Ken Kirkwood, Barry Lewis, David Reed, Suzanne Walker

Cover: Alastair Black
Page 4: John Garrett